TURNER: THE FIFTH DECADE

ANNE LYLES

Turner: The Fifth Decade

WATERCOLOURS 1830–1840

TATE GALLERY

EXHIBITION AND CATALOGUE SPONSORED BY
AGFA GRAPHIC SYSTEMS GROUP

The sponsorship of *Turner: The Fifth Decade* by Agfa
Graphic Systems Group has been recognised by an
award under the Government's Business Sponsorship
Incentive Scheme, which is administered by the Associ-
ation for Business Sponsorship of the Arts.

Cover
Venice: S. Maria della Salute,
Night Scene with Rockets *c.*1833–5
detail (cat.no.45)

ISBN 1 85437 089 8
Published by order of the Trustees 1992
for the exhibition of 12 February–10 May 1992
Copyright © 1992 The Tate Gallery All rights reserved
Designed and published by Tate Gallery Publications,
Millbank, London SW1P 4RG
Photography: Tate Gallery Photographic Department
Typeset in Baskerville. Typesetting and pre-press materials
supplied by Agfa Graphic Systems Group
Printed and bound in Great Britain by Balding + Mansell plc,
Wisbech, Cambridgeshire on Parilux Cream 150gsm

CONTENTS

FOREWORD

This is the fifth exhibition in our annual series surveying Turner's watercolours and drawings decade by decade. With a long-established reputation, by 1830 Turner was the most sought-after watercolourist of his day. In addition to commissions already in hand, such as the engraved topographical series *Picturesque Views in England and Wales*, during the 1830s Turner also took on important new ones, especially in the field of book illustration. The vignette designs he was engaged to make for the poetry of Rogers, Milton and Scott are all covered in the exhibition but those for the verse of Byron have been deliberately omitted since they will be examined more fully in the exhibition *Turner and Byron* which will take place in the Clore Gallery in the summer of 1992. Indeed the whole subject of Turner's vignette illustrations is currently being investigated by one of the present Volkswagen Turner Scholars, Dr Jan Piggott, and will form the subject of another exhibition in the Clore in the autumn of 1993.

Although, then, Turner was at this time busy with projects at home, the 1830s are perhaps best remembered for the watercolours which record his travels abroad. Some of these, such as the much-loved bodycolour studies for *The Rivers of France*, were made for engraving. Others, of Venice or views of Switzerland, are unfinished sketches, and whether in watercolour or bodycolour, on white or coloured papers, reveal the artist's continuing love of experimentation with his media. Some of the finest of these Continental colour sketches are those on blue paper showing views on the rivers Meuse and Mosel. These are at present the subject of a special exhibition in Brussels, curated by the Turner Scholar Dr Cecilia Powell, and could not therefore be shown here, although two comparable studies of other European rivers are included to represent the group.

The finished watercolours made by Turner for translation into engravings were often dispersed once they had been finished with and hence some series are poorly represented in the Turner Bequest; *Picturesque Views in England and Wales* is a case in point. As in previous years, the Gallery's holdings have been supplemented by a number of generous loans: from private collectors, from Birmingham Museums and Art Gallery, Blackburn Museum and Art Gallery, the British Museum, and the National Museums and Galleries on Merseyside, Lady Lever Art Gallery. We are most grateful to all owners for these

loans. It is particularly rewarding to see Turner's watercolour of 'Trematon', which had been lost sight of for many years, hanging side by side with the view by Scarlett Davis of Benjamin Godfrey Windus's library in which it features, along with other Turner watercolours in Windus's collection.

The exhibition has been selected and catalogued by Anne Lyles who is grateful for the help she has received from past and present Volkswagen Scholars at the Clore, Cecilia Powell, Peter Bower and Jan Piggott. Special thanks are also due to Ilse Baer, Pat Kattenhorn, Diane Perkins, Michael Snodin, Lindsay Stainton, Rosalind Turner, David Wallace-Hadrill and Stephen Wildman. Finally, we are most grateful to Agfa for sponsoring the exhibition and also most generously providing the typesetting and film for this catalogue.

<div align="right">Nicholas Serota <i>Director</i></div>

SPONSOR'S FOREWORD

Turner: The Fifth Decade is an exhibition and catalogue that Agfa are particularly pleased to sponsor. One reason is that our products are sold and supported within every major European country; therefore our association with a period when Turner travelled through so much of Europe seems entirely appropriate.

Another reason is that the Tate Gallery have granted us the privilege of taking an active role in the production of the catalogue as well as financially supporting the exhibition. As a leading company in the reprographic material technology field, we are delighted to have had the opportunity to demonstrate our capabilities in this publication: a variety of our electronic and photographic products have contributed to its production in typesetting, colour work and page make-up. As the existence of this catalogue proves, the results have met the high standards of the Tate Gallery. They also, I hope, demonstrate the excellence our products can achieve.

We thank the Tate Gallery for allowing us to make this contribution. If it has helped in any way towards people's appreciation of the works of a great artist at the peak of his powers, then our joint enterprise has been a success. Our involvement with the Tate Gallery has been both enjoyable and challenging. All of us at Agfa look forward to many more similar collaborations.

Gustav Ahrens *Managing Director*
Agfa (UK) Limited

INTRODUCTION

The death of Harriet Wells (the daughter of Turner's old friend William Frederick Wells) on New Year's Day 1830 was followed, a few days later, by that of a much-respected colleague, the portrait painter Sir Thomas Lawrence (see cat.no.1). Only the previous year Turner's father had also died, prompting the artist to make a will and in 1831, at the age of fifty-six, he signed another one. Yet despite such an inauspicious start, this decade was to prove the most remarkable of them all; the sheer range, quality and quantity of Turner's output in the 1830s, in watercolour and oils, are unparalleled in any other period of his career.

Towards the end of the previous decade Turner had been engaged by the banker, connoisseur and poet Samuel Rogers to make twenty-five vignette designs (that is small, borderless images designed to function as headpieces or tailpieces) for a new illustrated edition of his long poem, *Italy*. When the book appeared in 1830 – it may not actually have been published until December, but was certainly circulating as early as August[1] – it attracted magnificent reviews: 'the most splendid piece of illustrated topography it has ever been our fortune to look on' reported *The Atheneum* (August 1830). Although Turner's vignettes were not the only illustrations to the book (there were also designs after Thomas Stothard and Samuel Prout, for example), it was clear that they were its chief attraction and, indeed, the source of its novelty. *The Atheneum* called the vignettes 'jewels', referring no doubt not only to their small-scale and inherent beauty but also to their delicate execution; for they had been engraved on the recently introduced steel plates whose hardness (by comparison with copper) dictated the use of a much finer style of engraving, as well as enabling much larger print runs to be obtained.

The unqualified success of the 1830 edition of *Italy* prompted Rogers, almost immediately, to commission from Turner a similar set of designs for a volume of his collected *Poems* (see cat.nos.9–13). But the ramifications of *Italy*'s new format were not lost on other sections of the trade. The Edinburgh publisher Robert Cadell, already planning a new illustrated edition of the poetical works of Sir Walter Scott, now determined to engage Turner as sole illustrator, promising in a letter to Scott that 'with his pencil I will insure the sale of 8,000 of the Poetry – without, not 3,000' (28 March, 1831).[2] The commission was of

course as much of a coup for Turner as it was for Cadell, for whilst Rogers was a minor poet, Scott was by contrast (with Byron, whose verse Turner was to illustrate later in the decade) one of the most celebrated romantic authors of the day. Indeed Turner's reply to Scott's invitation to stay at Abbotsford (see cat.no.4) contains a strong hint of deference, revealing it would seem that he was not a little in awe of this literary giant.[3]

Late in July 1831 Turner set off for Scotland, and after staying with Scott in the Border country, continued his tour to the north and west of the country in search of material for the *Poetical Works*. His trip to the island of Staffa on the steamboat the *Maid of Morven* proved a particularly memorable experience, and was recorded in an oil painting he exhibited at the Royal Academy the following year (fig.1). When the picture was later sold to James Lenox, of New York, Turner described to him the episode which it takes as its subject. The captain of the steamboat, Turner explained, had intended to take the crew on to Iona after the trip to Staffa, but seeing 'such a rainy and bad-looking night coming on' decided instead 'to steam thrice round the island in the last trip. The sun getting towards the horizon, burst through the rain-cloud, angry, and for wind; and so it proved, for we were driven for shelter into Loch Ulver, and did not get back to Tober Moray before midnight'.[4] In the same letter Turner described how, a

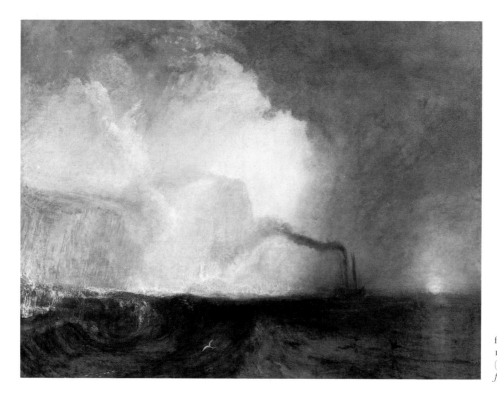

fig.1 'Staffa, Fingal's Cave', R A 1832, oil on canvas, 915 × 1220 (36 × 48) (B & J 347). *Yale Center for British Art, New Haven*

little earlier, he and a few others had managed to get inside Fingal's Cave. The sketches he made during that adventurous foray gave rise to perhaps the very finest of all his vignettes to the *Poetical Works*, that of 'Staffa's Cave' (see cat.no.7) – although his illustration of 'Lake Coriskin' on the isle of Skye, which follows a more traditional landscape format, is an equally dramatic image (cat.no.8).

Although Turner's illustrations to Scott always have a direct literary reference, nevertheless they are firmly grounded in topography. In the designs which he made for Samuel Rogers's *Poems*, however, Turner distanced himself more radically than before from the topographical base of his subjects. These watercolours – whether for the poems 'To an Old Oak' (cat.nos.9–10), 'The Alps at Daybreak' (cat.no.11), 'Human Life' (cat.no.12) or 'The Voyage of Columbus' – all illustrate with much greater precision than before the events described in the text. This narrative tendency is still more pronounced in the illustrations which Turner made later in the decade to the poetry of John Milton (cat.nos.53–4) and Thomas Campbell. The finished watercolours for both these series were, like so many others made by Turner for engraving projects, dispersed to private collectors once the engravers had finished with them, and are thus not represented in the Turner Bequest. All twenty of the artist's designs for the *Poetical Works of Thomas Campbell* (1837) were only recently acquired by the National Gallery of Scotland (although the series is fully represented in the Tate by a fine set of the engravings). Meanwhile, just as this catalogue was in the course of preparation, the Tate Gallery succeeded in purchasing one of Turner's illustrations to Milton's *Poetical Works* (1835), 'The Temptation on the Pinnacle' (fig.2), thus filling a particularly important gap in its holdings. The series is represented in the exhibition by a colour study for a design no doubt intended as an illustration to *Paradise Lost*, although never taken any further (cat.no.53); and an impression of the print by Edward Goodall of 'The Fall of the Rebel Angels' (cat.no.54), which makes an interesting comparison with the large watercolour of the subject by Edward Dayes also recently acquired by the Gallery (fig.3).

Some of the book illustrations Turner was commissioned to make during this decade were of distant destinations which he himself had never visited, and for these he was forced to rely on drawings by others. Many of the watercolours Turner made early in the 1830s of Greece and other parts of the Mediterranean for *The Works of Lord Byron*, for example, were worked up by him from drawings by the minor professional topographer William Page (1794–1872) and the

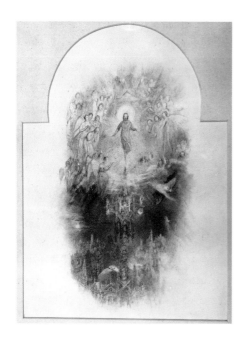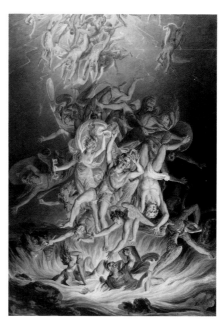

architect Thomas Allason (1790–1852). Indeed elaborating drawings by others, often amateurs, now became an important feature of Turner's work for the engraver. His designs for Finden's *Landscape Illustrations of the Bible*, for example, were made from sketches by a variety of artists, ranging from names as obscure as 'Major Felix' or the 'Reverend R. Master' to that of the well-known architect, Sir Charles Barry (1795–1860); whilst those for White's *Views in India* (1836–7) were all elaborated from drawings by Lt.-Col. George Francis White himself (see cat.nos.55–6). Indeed, three pencil drawings by White relating to this project were recently purchased by the Gallery, and one of them, 'View near Jubberah' (cat.no.55), is included here alongside the much smaller watercolour version of the subject made by Turner using White's drawing as a model. The comparison serves to emphasise how adept Turner had become at compressing and concentrating his information into a small area.

In addition to these small watercolours made as book illustrations, throughout the decade Turner continued to paint larger finished watercolours of his native scenery which were destined for publication, in parts, as copper-plate engravings. Perhaps the most famous and certainly the finest of all these topographical series is *Picturesque Views in England and Wales* which had been launched in the mid-1820s by the enterprising engraver-publisher Charles Heath, but which continued to appear in part form throughout most of the 1830s. The Tate owns a single watercolour for this series, 'Aldeburgh',[5] dating from circa 1826

(although the later watercolour, 'Merton College, Oxford' in the Turner Bequest, cat.no.18, may well have been intended for it as well). 'Trematon' and 'Dudley' (cat.nos.14 and 16), both of which have been borrowed for this exhibition, are excellent examples of the great range of landscape types which *England and Wales* encompasses: the former is an English pastoral subject cast in the language of Claude, whilst the latter is more unusual in the series in depicting an industrial scene, although it is only one of a number of representations of industry in Turner's work as a whole – including from this decade, for example, the famous oil 'Keelmen Heaving in Coals by Night', 1835 (B & J 360).

The 1830s are also notable for the emergence of a new group of patrons of Turner's work, a context in which both 'Trematon' and 'Dudley' are particularly relevant. 'Trematon' was acquired by one of the most enthusiastic of all these later patrons, Benjamin Godfrey Windus, and can be seen hanging alongside other Turner watercolours from his collection in the view of his library by John Scarlett Davis dating from 1835 (cat.no.15). Indeed Windus was known for the 'liberality' with which he opened up his house at Tottenham Green, North London, for the benefit of visitors, and it was to become something of a place of pilgrimage for artists and connoisseurs alike. One of the most regular visitors there was the youthful John Ruskin, who found the advantage of being able to see such a large group of Turner watercolours collected together in one place 'inestimable' (see under cat. no.15).

Although Ruskin did not start purchasing Turner's work until 1839 – 'Dudley' was owned by him from 1843[6] – it was in the 1830s, by his own admission, that he first became 'aware of [Turner's] power'.[7] In 1836 *Blackwood's Magazine* published a virulent criticism of Turner's art by the Reverend John Eagles, whose harshest words were directed towards the oil painting 'Juliet and her Nurse' (see cat.no.43) in which 'poor Juliet', he wrote, 'has been steeped in treacle to make her look sweet'. It was the viciousness of these criticisms which fired Ruskin 'to the height of black anger' and prompted him to compose the famous letter in defence of Turner's art containing the germ of what was to become his great work, *Modern Painters*. The painting itself was purchased by the third of these important new patrons to emerge during the decade, the Ross-shire landowner, Hugh Andrew Johnstone Munro of Novar, with whom Turner was to travel to Switzerland in 1836.

In 1878 Ruskin, by this date overwhelmed by the effects of industrialisation on English life and scenery, wrote of 'Dudley' (still at that

time in his possession) that it represented Turner's 'full understanding of what England was to become' (see under cat.no.16). However, Ruskin is here speaking from the standpoint of the later nineteenth century when the landscape created by the Industrial Revolution had ceased to appear in any way 'sublime'. In fact Turner's watercolour, painted at a time of considerable pride in the accomplishment of industrial enterprise, reflects both his fascination with technological change and also his love of the contrast between the old and the new. In this respect Turner is very much a child of the eighteenth century; his watercolour of Dudley is a work alive with energy and activity, and shows the same sense of excitement for the new industrial age that had been heralded by Joseph Wright of Derby – in paintings like 'Ark-wright's Cotton Mills by Night'[8] – about fifty years before.

A colour study by Turner of about the same date as 'Dudley', cat.no.17, showing the sun's light diffused through an artificial fog of haze and smoke, is a remarkably radiant image. Although not certainly related to the evolution of 'Dudley' itself, this watercolour is typical of a group of similar studies in the Turner Bequest, often known as 'colour beginnings', many of which are in fact related to the series *Picturesque Views in England and Wales*. Others, however, can be connected with different projects, and it is suggested here that the five large colour studies of Oxford High Street (cat.nos.21–6) which have usually been associated with a single, abandoned subject for *England and Wales* may in part have been made in connection with a different commission for the Oxford printseller, James Ryman. Another group of colour studies made in this decade are those of a conflagration across water (cat.nos.50–1) which are traditionally identified as showing the burning of the old Houses of Parliament in 1834, a subject also treated by Turner in two canvases exhibited at the Royal Academy and British Institution the following year (fig.4). Another, more advanced but still unfinished watercolour in the Turner Bequest shows the fire-fighters in Palace Yard (cat.no.52).

Although undoubtedly one of the most important of all the engraved series after Turner's work, from a commercial point of view *Picturesque Views in England and Wales* was a failure; after suffering a tortuous number of changes in publisher, the series was brought to a premature close in 1838. Not only were the prints almost certainly overpriced by comparison with rival publications (copper had been used for the series in preference to the more hard-wearing and economical steel), but the plates themselves would probably have appeared old-fashioned by the 1830s.[9] The tradition of picturesque and antiquarian views had

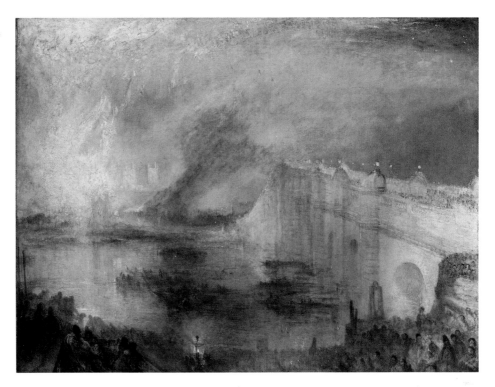

fig.4 'The Burning of the House of Lords and Commons, 16th October, 1834', British Institution 1835, oil on canvas, 920 × 1230 (36¼ × 48½) (B & J 359). *The Philadelphia Museum of Art*

been a long-established one in Britain, but the resources of the native landscape had by now been thoroughly quarried. The reopening of the Continent after the end of the Napoleonic wars had promoted an increase in foreign travel among the middle classes and a new interest in the European scene. Travellers from the 1820s were no longer, like their eighteenth-century predecessors, Grand Tourists in search, above all, of the classical past – no longer *virtuosi, dilettanti* or *cognoscenti*; rather they were businessmen or professionals, as much interested in the life and colour of their contemporary surroundings, and travelling mostly for change or pleasure.[10] (John Ruskin's father, a sherry merchant, is typical of this new breed of traveller – and indeed many of the young Ruskin's summers were spent with his parents on extensive tours on the Continent). A new form of travel literature now arose to cater to this taste for the Continental picturesque.

One of the publishers quick to take advantage of the new vogue for Continental topography was Charles Heath. Having only recently engaged Turner's services for the series *Picturesque Views in England and Wales,* and eager as ever to capitalise on the artist's skills and reputation, in the late 1820s Heath approached Turner for a set of drawings of French river scenery as well. Engraved on steel, and published in three volumes between 1833 and 1835, *The Rivers of France* (as they are

generally known) were actually issued under the general title of *Turner's Annual Tour*, and indeed should be seen against the background of the newly fashionable pocket literature known as 'annuals'. For although they are essentially illustrated travelogues rather than – as were most of the other annuals – anthologies of poetry and prose, nevertheless in their format and price, and in the size of their plates, *The Rivers of France* are a characteristic production of the genre; and, like the other annuals, they were actually issued in the autumn before the year given as the date of publication so as to capture the Christmas market (see under cat.no.3).[11]

One of the best-known of these annuals devoted to a miscellany of poetry and prose was *The Keepsake*, launched by Charles Heath in 1827, for which seventeen of Turner's watercolours were engraved over the following ten years (see under cat.no.3). 'The Falls of the Rhine at Schaffhausen' (cat.no.2), engraved for *The Keepsake* in 1833, is however considerably larger than would have been required for translation in an octavo-sized volume, and was probably not made by Turner expressly for it (as was perhaps also the case for his other watercolours engraved for this publication). His drawings for *The Rivers of France* were, by contrast, made especially for that project, even though executed in a medium, bodycolour (that is watercolour mixed with opaque white), which he usually reserved for more informal or experimental sketches such as the group of Venetian subjects on brown paper of circa 1833–5 (cat.nos.42, 44–9). Indeed the designs for *The Rivers of France* are the only ones ever made by Turner in bodycolour for translation into engraved form (see under cat.no.27).

Nevertheless these views of French river scenery, particularly those charting the course of the Seine (cat.nos.27–8, 30, 32–6), are some of the most delightful subjects Turner ever painted, testimony to Ruskin's comment that 'of all foreign countries, Turner has most entirely entered into the spirit of France'.[12] Sometimes Turner presents the Seine as a scenic route, as for example in cat.no.27 where he includes a group of tourists in a boat enjoying the distant prospect of the abbey of Jumièges; at other times, such as in the view 'Between Quilleboeuf and Villequier' (cat.no.30), he reminds us that the river is a busy commercial waterway – this design, indeed, is also of particular interest, as its juxtaposition of a steamboat with a sailing vessel anticipates one of Turner's most famous oils of the decade (if not of his entire career), 'The Fighting "Temeraire"' (fig.5). The views of Paris, meanwhile, are notable for a particularly attractive blond palette (cat.nos.34–8). However, from a colouristic point of view, perhaps the

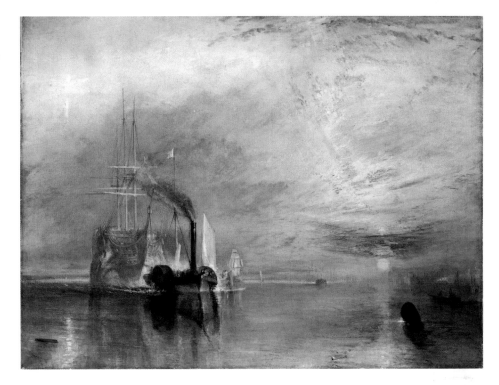

most ravishing of all these blue paper bodycolour studies of river
scenery are those of other locations in Europe, presumably executed in
connection with the larger scheme, the 'Great Rivers of Europe', for
which *The Rivers of France* was originally intended to form only a part.
Those drawings showing views on the rivers Meuse and Mosel have
recently been redated by Cecilia Powell to 1839 (they were previously
thought to have been executed in 1834), and can now be seen as what
was probably 'the grand finale to [Turner's] works on blue paper'.[13]
Others (cat.nos.40−1) still await a firmer identification and date.

Powell's redating of Turner's trip to the rivers Meuse and Mosel to
the year 1839, invaluable as it has proved, has nevertheless − in her
own words − served 'as a somewhat uncomfortable reminder of just
how much work still remains to be done on Turner's Continental tours
of the 1830s': as she points out, his movements in this decade are far
less well documented than those of the 1820s and 1840s.[14] Indeed the
redating here of a simple, rapid sketch on folio 31 of the *Dresden and
Berlin* sketchbook (cat.no.57), showing the portico of the recently
opened Altes Museum in Berlin, not only serves to underline the
validity of the comment but also to indicate how nothing can be taken
for granted about Turner's Continental tours of the 1830s until more
thorough investigation has been undertaken.

This sketchbook was used by Turner on an extensive tour round central Europe he is known to have undertaken at some point during the decade, although the exact date of the tour has long been the subject of speculation. For many years it was accepted as having taken place in 1835: Finberg tells us that about this time Turner 'had heard much talk among his fellow Academicians of the fine picture galleries of Dresden and Vienna', and that he also wanted 'to see something of Heligoland, Germany, and Austria' in connection with the commission to illustrate Thomas Campbell's poems [15] (the precise date of this commission is not in fact known, but assumed to be circa 1835). Finberg also believed 1835 to be the year that Turner made his second visit to Venice – for it had long been thought that the artist must have made a visit to the city at some stage in the 1830s, in addition to the other two he made there in 1819 and 1840.

However, a few years later another Turner scholar, Hardy George, redated the artist's second visit to Venice to 1833 on the strength of a reference in the *Gazzetta Privilegiata di Venezia* for 9 September of that year which stated that 'Turner, gent. inglese' had arrived that day from Vienna. Although the *Gazzetta's* record of arrivals and departures from the city was not always infallible, and whilst 'Turner' is a common enough name, the probability that this 'Turner' was indeed the artist does seem to be lent weight by the existence of a sketchbook in the Bequest, the *Lintz, Salzburg, Innsbruck, Verona and Venice* sketchbook (TB CCCXI) which contains studies of Vienna as well as of those cities mentioned in the title. [16] More recently, Hardy George dated the rest of the related Continental itinerary – that is to say Turner's visit to Germany and Bohemia – to the year 1833 as well, on the grounds of an additional motive for the trip, namely that Turner wished to compare the housing of the first public collections in Europe. [17]

Certainly on 20 June, 1832, Turner had been appointed to a committee to discuss a new building for the National Gallery and Royal Academy (the National Gallery was then housed in 100 Pall Mall, the former home of John Julius Angerstein whose collection, purchased by the government, formed the nucleus of the new institution, together with the paintings recently presented by Sir George Beaumont). Furthermore in the same sketchbook he used for making studies of the exterior and inner portico of the Altes Museum in Berlin (cat.no.57), Turner also jotted down a number of rapid pencil notes of some of the celebrated paintings in the Dresden Art Gallery – considered, together with the important galleries at Berlin and Munich, as one of the best collections of pictures in central Europe at that time. [18]

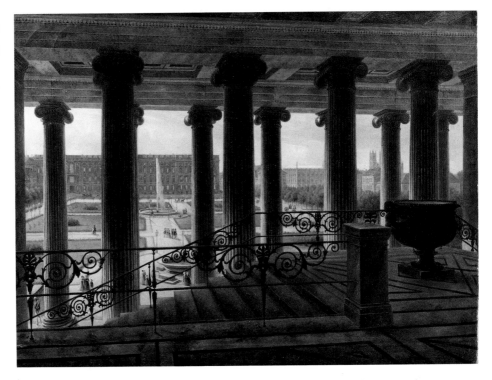

The problem with this most recent theory lies not, then, with Turner's additional motive for the trip – it is rightly emphasised here by Hardy George for the first time – but in the suggested date of the tour itself. For Turner's sketch of the Altes Museum's portico (cat.no.57) shows *in situ* the copy of the Warwick Vase which had been presented to King Friedrich Wilhelm III by the Tsar of Russia, and which had been installed in the middle of January 1834 – its exact position at the top of the double flight of stairs can be seen more clearly in a painting by Carl Daniel Freydanck (fig.6).

It is, then, clear that Turner could not have made his tour to central Europe before 1834 at the earliest. The years 1834 or 1835 are in fact the most likely dates for the tour, given that it is unlikely to postdate 1835: Turner would almost certainly not have had the time or energy for such an expedition in 1836 in addition to travelling that summer to the Val d'Aosta with Munro of Novar; and assuming the chief motives for the trip to be those already stated (although there is, of course, the further possibility that he wished to collect material for the 'Great Rivers of Europe' project), the years 1837 and 1838 – the two remaining possibilities – would have been too late since they saw, respectively, the publication of Moxon's *Poetical Works of Thomas Campbell* and the completion of the new National Gallery building designed by William Wilkins and officially opened on 9 April 1838.

However, the issue as to whether 1834 or 1835 is the more likely year for Turner's tour to central Europe is complicated by a lack of any secure itinerary. For example, if Turner did visit Venice in 1833 – and assuming he did arrive from Vienna as the *Gazzetta* stated – then, as has been seen, the sketchbook documenting his route from Vienna, the *Lintz, Salzburg, Innsbruck, Verona and Venice* sketchbook, must belong to 1833 rather than 1835. It may therefore be the case that Turner's visit to central Europe was not as extensive as has sometimes been supposed. Perhaps after travelling through Berlin and Dresden to Prague, Turner then made his way home through other parts of Germany, such as Nuremberg and Frankfurt, as is implied by the existence of another sketchbook also associated with the tour, the *Rhine, Frankfurt, Nuremberg and Prague* sketchbook (see under cat.no.58). Turner might just have managed to fit in such a slimmed-down version of the tour in the summer of 1834, between the dates of 9 August when he was in London and 15 September when he was in Edinburgh,[19] but the summer of 1835 seems much more likely. (There is, in addition, the possibility that Dr Gustav Friedrich Waagen, the art historian and director of the Altes Museum in Berlin, who in his own words 'made a point of looking for the landscape [*sic*] of the favourite painter Turner'[20] during his visit to England in 1835, might perhaps have met the artist that year and persuaded him to visit Berlin.) If Turner's tour to central Europe did take place in 1835, then it can be seen as an example of how the wheel of Turner scholarship has moved full circle.

Given that Turner's second trip to Venice is still assumed to have taken place in 1833, there is the further question to consider as to why the magnificent series of Venetian bodycolour sketches he made on brown paper (cat.nos.42, 44–9) seem more likely to date from 1835 than to 1833 itself: for many of their themes share undeniable parallels with the evolution of the oil painting 'Juliet and her Nurse' of 1836 (see especially under cat.nos.42–3), whilst one of them, cat.no.48, may even have been directly inspired by an oil painting exhibited by William Etty at the Royal Academy in the spring of 1835. In fact these studies have a highly expressive and experimental character which is entirely in keeping with the likelihood that they are reminiscences made away from the motif; certainly they are very different from the watercolours of Venice associated with Turner's later trip to the city in 1840, some of which may actually have been coloured 'en plein air'. Of course Turner's visit to Venice in 1833 might have been followed by another one in 1834 (even, conceivably, by one in 1835). However a gap of two years between a visit to the city and the date of these brown

paper studies is not difficult to explain when one remembers that the artist painted two oils of Venice for the 1833 spring Academy exhibition – 'Bridge of Sighs, Ducal Palace and Custom-House, Venice: Canaletti Painting' (B&J 349) and 'Ducal Palace, Venice' (B&J 352) – as much as fourteen years after his previous trip to the city, in 1819.

By comparison with the dating and itinerary of Turner's tour to central Europe, the tour he undertook in 1836 to the Val d'Aosta with his friend and patron Hugh Munro of Novar is fairly well-documented and straightforward (see under cat.no.59). Turner was by now sixty-one, yet most of the sketches he made in the Aosta valley are from places that could only have been reached by climbing on foot up steep and narrow paths on the mountain sides [21] (see also cat.no.59). No finished watercolours resulted from the trip, although a large group of colour studies have been associated with it, many of them probably made in the 'roll' sketchbooks (that is to say sketchbooks with soft backs which could be rolled up in a pocket) that Turner was by now accustomed to take with him on his tours abroad. However, these sketchbooks are now dismantled, and their contents have become mixed up with other loose sheets in the Bequest, making identification and dating very difficult (cat.nos.60–5). Studies showing mountains or valleys certainly visited on the tour, such as cat.nos.60–1, do not pose particular problems. But others, for example cat.nos.62–5, could date from other tours to the Alps, perhaps undertaken later in the 1830s; cat.nos.62–3 may even date from the early 1840s. Cat.nos.60–1 and 64–5 share a mood, not of awe or fear as had been the case for Turner's earlier Alpine views, but of expansion and exaltation in front of nature. [22] Cat.nos.64–5 are studies of the same mountain, treated with slight variations of light and viewpoint, anticipating Turner's approach to some of his Swiss views in the first half of the 1840s, in particular those of the Rigi mountain from across Lake Lucerne. The oil painting Turner produced the year after this trip, 'Snow-Storm, Avalanche, and Inundation – a Scene in the Upper Part of the Val d'Aosta' (B&J 371), is by contrast very dark in tonality and full of sublime and cataclysmic incident – an exception to Turner's developing response to the Alps at this time.

Turner's trip to Venice in 1840 marks something of a climax to an extraordinary and highly productive decade. It inspired a large sequence of evocative coloured studies of the city made during or shortly after the trip (cat.nos.66–70), but none of them were elaborated by Turner into finished watercolours, perhaps – it has been suggested – because their intangible magic discouraged him from

developing them any further.[23] However, soon afterwards, collectors like John Ruskin managed to get possession of several of the more finished sheets, mostly it would appear taken from the roll sketchbook whose remaining contents are still identifiable in the Turner Bequest[24] (TB CCCXV; see cat.nos.67 and 70). Ruskin would have acquired them either from Turner himself, or more likely through the agent the artist was now using, Thomas Griffith. It was, indeed, at Griffith's house at Norwood that in 1840 Ruskin met Turner for the first time – four years after the occasion when he had leapt to the artist's defence following the criticisms of 'Juliet and her Nurse'. Ruskin recorded the meeting in his diary with these words: 'Introduced to-day to the man who beyond all doubt is the greatest of the age; greatest in every faculty of the imagination, in every branch of scenic knowledge; at once *the* painter and poet of the day, J.M.W. Turner.'[25] Many years later, after a long and sustained period spent analysing the artist's life and work, he was to write of the years 1830–40 as a time when Turner 'produce[d] his most wonderful work in his own special manner, – in the perfect pieces of it, insuperable'.[26]

Notes

(for abbreviated references, see Bibliography)

[1] Powell 1983, p.3
[2] National Library of Scotland, MS 3917, fol.142
[3] Gage 1980, no.169; and see Wilton 1987, p.193
[4] Gage 1980, no.288
[5] N05236, repr. Warrell 1991, no.36
[6] Purchased March 1843, according to an entry in his father's account book (see H Shapiro (ed.), *Ruskin in Italy: Letters to his Parents 1845*, Oxford 1972, p.83 n.1
[7] Ruskin 1878, p.9
[8] See J. Egerton, *Wright of Derby*, exh. cat., Tate Gallery 1990, no.127
[9] Herrmann 1990, p.139
[10] M. Hardie, *Watercolour Painting in Britain*, 3 vols., 1966–8; see vol.3, 1968, pp.1–2
[11] Alfrey 1982, pp.192–3
[12] *Modern Painters*, quoted Alfrey, ibid.
[13] Powell 1991, p.46
[14] Powell 1991, p.48
[15] Finberg 1961, p.355
[16] Stainton 1985, p.21 and n.36, usefully summarises George's conclusions
[17] George 1984, p.18
[18] George 1984, p.3; the sketches are on ff.6–7 verso
[19] Powell 1991, pp.46–7
[20] Although he was not impressed by what he saw; see G.F. Waagen, *Works of Art and Artists in England*, 1838, pp.151–2
[21] Finberg 1961, p.361
[22] Wilton 1980, p.173
[23] Wilton 1982, p.59
[24] Stainton 1985, pp.23 and 27
[25] Quoted Finberg 1961, p.380
[26] Ruskin 1878, p.9

9 **An Old Oak** *c.*1832

10 **Shipbuilding (An Old Oak Dead)** *c.*1832

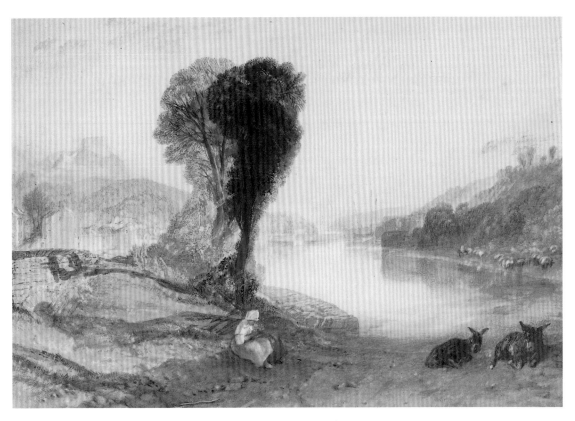

14 **Trematon Castle, Cornwall** *c.*1829

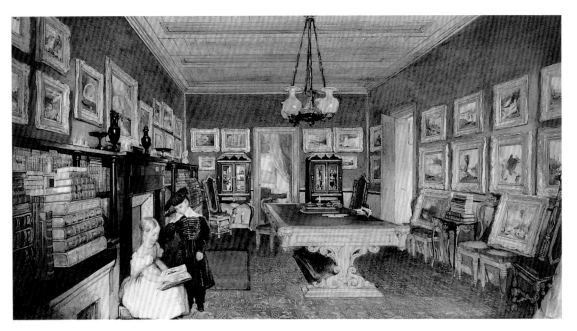

15 JOHN SCARLETT DAVIS **The Library at Tottenham,
the Seat of B.G. Windus, Esq.** 1835

17 **Colour Study: An Industrial Town
at Sunset, ? Dudley** *c.*1830–2

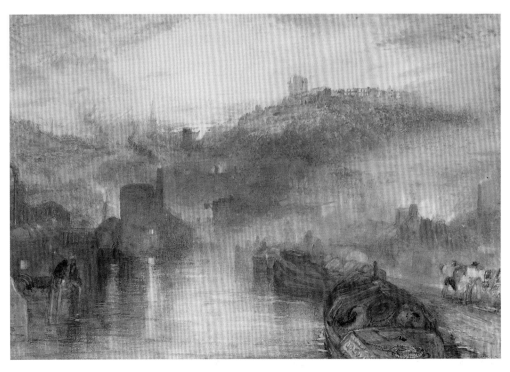

16 **Dudley, Worcestershire** *c.*1832

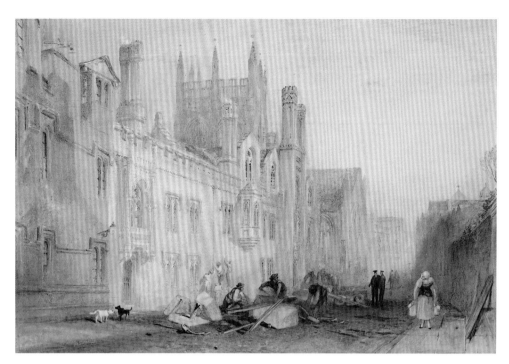

18 **Merton College, Oxford** *c.*1835–8

24 **Colour Study: The High Street,**
Oxford *c.*1837–9

25 **Colour Study: The High Street,
Oxford** *c.*1837–9

26 **Colour Study: The High Street,
Oxford** *c.*1837–9

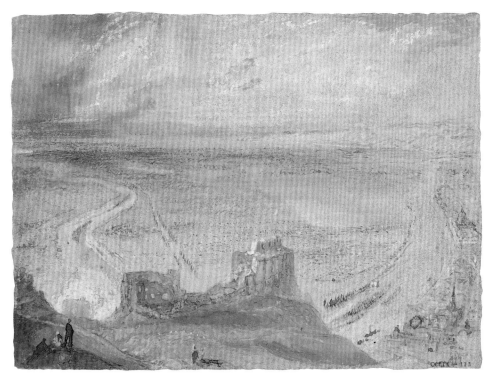

32 **Château Gaillard, from the East** *c*.1832

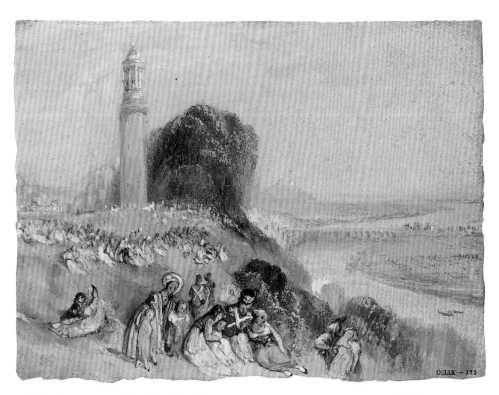

33 **The Lanterne at St Cloud** *c*.1832

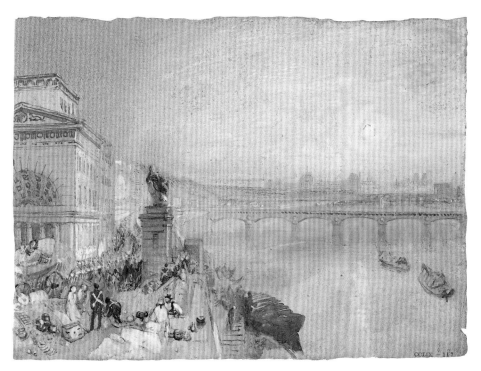

34 **Paris: View of the Seine from the Barrière de Passy, with the Louvre in the Distance** *c.*1832

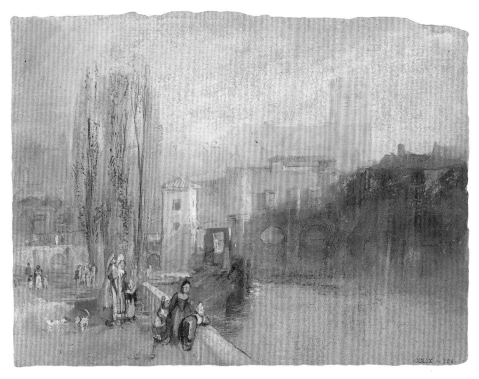

36 **Troyes** *c.*1832

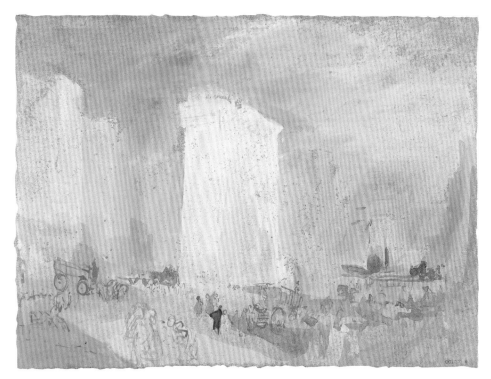

37 **Paris: the Porte St Denis** *c*.1832

38 **Study of a Group of Buildings,
probably in Paris** *c*.1832

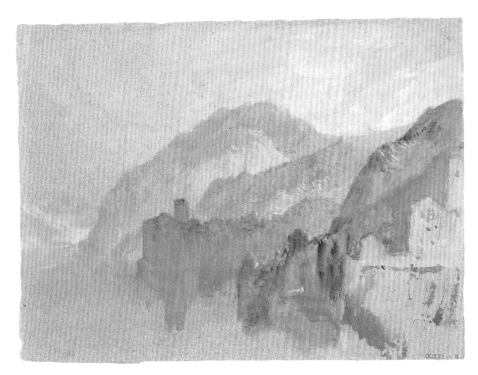

41 **Buildings by a Lake** *c.*1835–9

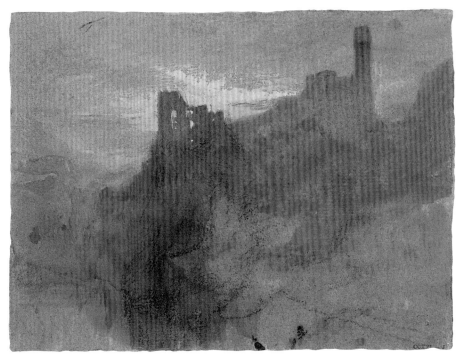

40 **Sunset over a Ruined Castle
on a Cliff** *c.*1835–9

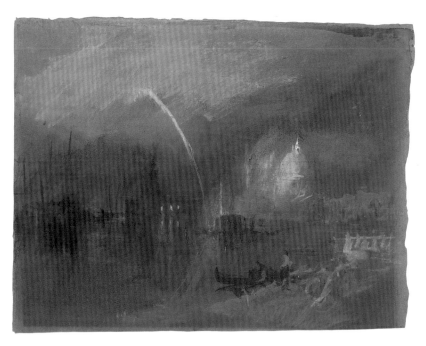

45 **Venice: S. Maria della Salute,**
Night Scene with Rockets *c.*1833–5

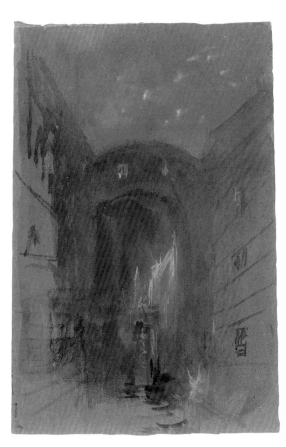

48 **Venice: The Bridge**
of Sighs, Night *c.*1833–5

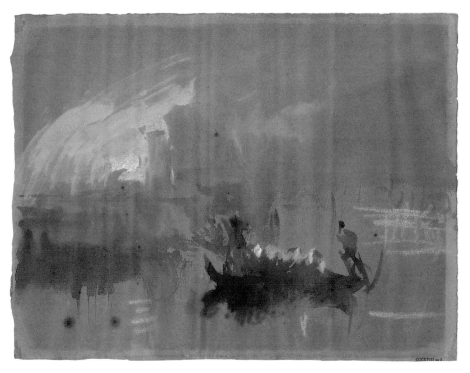

47 **Venice: Moonlight** *c.*1833–5

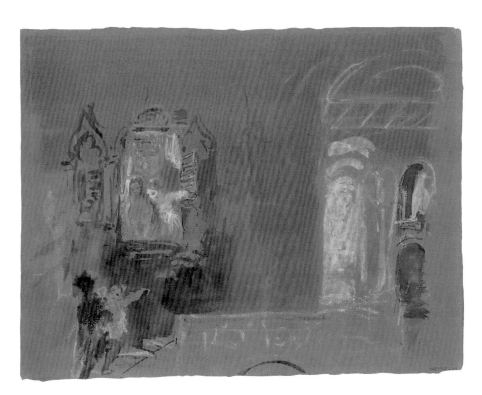

44 **Venice: The Lovers, ? a Scene
from 'Romeo and Juliet'** *c.*1833–5

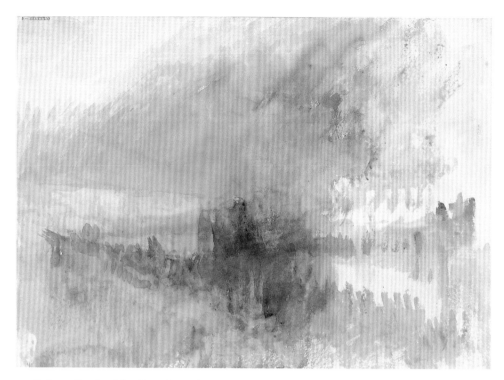

51 **Colour Study: The Burning of
the Houses of Parliament** 1834

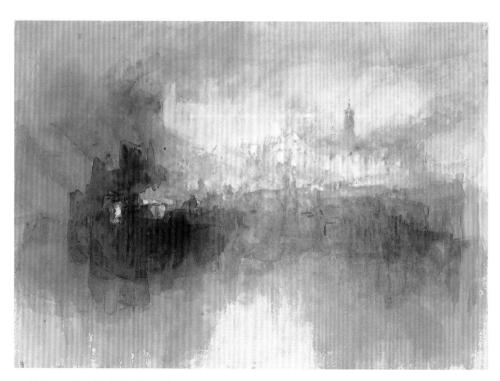

50 **Colour Study: The Burning of
the Houses of Parliament** 1834

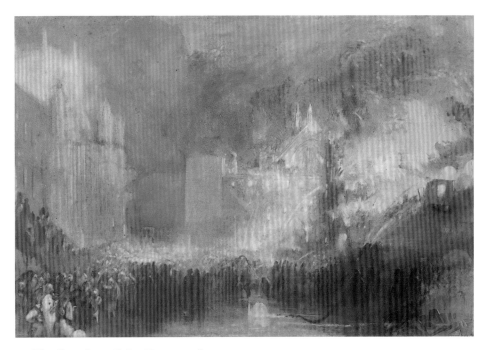

52 **The Burning of the Houses of
Parliament** 1834

53 **Satan Summoning his Legions** *c.*1834

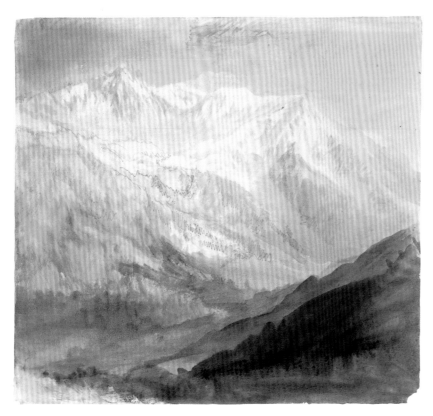

60 **Mont Blanc, ? from Brévent** *c.*1836

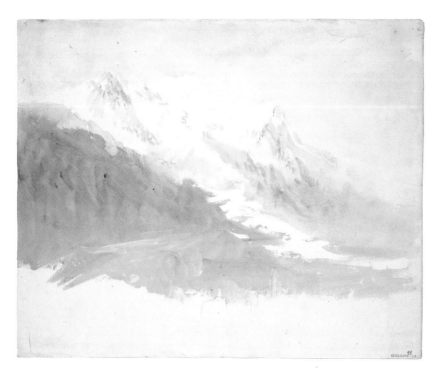

61 **Colour Study: Mont Blanc,
? from Brévent** *c.*1836

62 **Mountains, with Houses and**
Figures in the Foreground: ? View
near the Pass of Faido *c.*1836

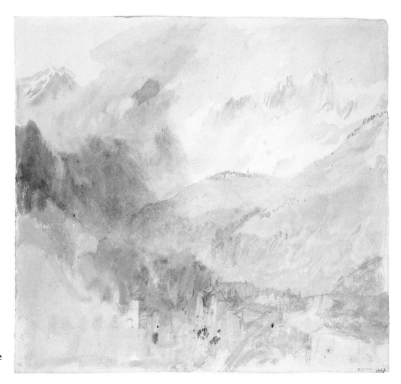

63 **Mountains: ? View near the**
Pass of Faido *c.*1836

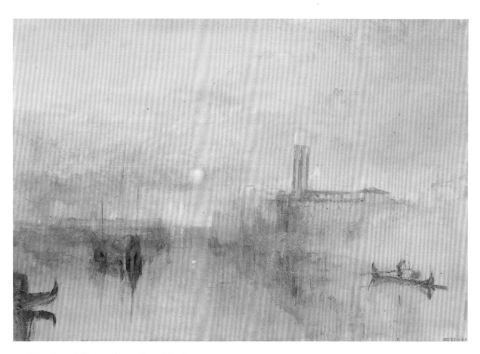

70 **Venice: Moonrise, the Giudecca
and the Zitelle in the Distance** *c.*1840

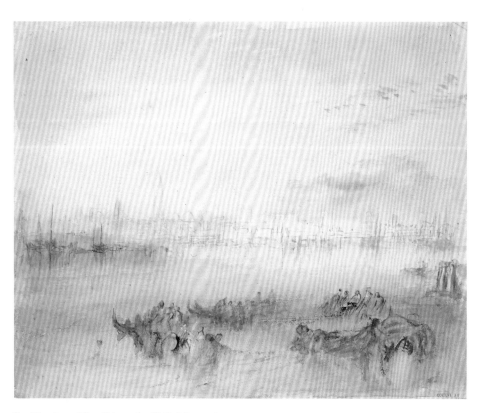

69 **Venice: The Riva degli Schiavoni
from the Channel to the Lido** *c.*1840

CATALOGUE

Unless otherwise stated, all works are by J.M.W. Turner. All measurements are given in millimetres followed by inches in brackets, height before width. For prints, the image size is given first, followed by paper size (for prints on india paper, the dimensions of the whole sheet are given) and plate-mark where appropriate. For books containing engraved images, measurements relate to the double-page spread rather than to the image. Works illustrated in colour are marked with an asterisk.

Abbreviations

B&J Martin Butlin and Evelyn Joll, *The Paintings of J.M.W. Turner*, 2 vols., revised ed. 1984

R W.G. Rawlinson, *The Engraved Work of J.M.W. Turner, R.A.*, 2 vols., 1908 and 1913

TB A.J. Finberg, *A Complete Inventory of the Drawings of the Turner Bequest*, 2 vols., 1909

W Andrew Wilton, *The Life and Work of J.M.W. Turner*, 1979 (catalogue of watercolours)

RA Exhibited at the Royal Academy

For other published material which is abbreviated in the text, see Bibliography.

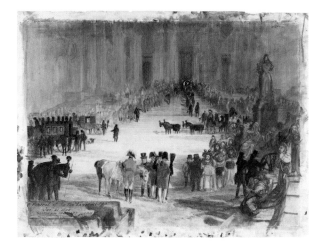

1 **Funeral of Sir Thomas Lawrence: A Sketch from Memory** RA1830
Watercolour and bodycolour
616 × 825 (24¼ × 32½)
Inscribed bottom left: 'Funeral of Sir Thos Lawrence PRA / Jany 21 1830 / SKETCH from MEMORY IMWT'
Turner Bequest; CCLXIII 344
D25467
W521

The death of Turner's father on 21 September 1829 was followed by the passing of several other friends and acquaintances during the following months: the painter and Academician, George Dawe, in October 1829, at whose funeral at St Paul's Cathedral Turner was a pall-bearer; Harriet, the daughter of his old friend William Frederick Wells, on 1 January 1830; and the portrait-painter Sir Thomas Lawrence on 7 January 1830.

Lawrence had been one of the first to notice and to encourage Turner's talents, and in the early 1820s had helped obtain the artist's only royal commission, 'The Battle of Trafalgar' (National Maritime Museum; B&J 252). So many deaths in close succession made Turner painfully aware of his own mortality. For on 22 January, the day after the funeral, he wrote to his friend, George Jones, in Rome: 'Alas! only two short months Sir Thomas followed the coffin of Dawe to the same place. We were then his pall-bearers. Who will do the like for me, or when, God only knows how soon. My father's death proved a heavy blow upon me, and has been followed by others of the same dark kind. However, it is something to feel that gifted talent can be acknowledged by the many who yesterday waded up to their knees in snow and muck to see the funeral pomp swelled up by carriages of the great' (Gage 1980, no.161).

This large watercolour, showing the funeral procession arriving at the steps of St Paul's, was exhibited at the Royal Academy in 1830; it is Turner's personal act of homage to a respected colleague. The watercolour well evokes the crisp, chill air of a cold January day. A group of women to the right have their hands tucked inside their muffs, their shoulders huddled forward with the cold.

the episode which occurs in the foreground: 'One of the gens-d'armes is flirting with a young lady in a round cap and full sleeves, under pretence of wanting her to show him what she has in her bandbox' (*Modern Painters*, pt.VIII, chap.II).

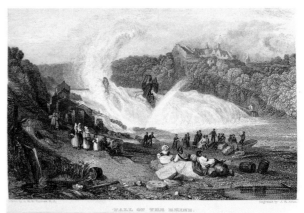

FALL OF THE RHINE NEAR SCHAFFHAUSEN.

288

2 The Falls of the Rhine at Schaffhausen

1831–2
Watercolour and bodycolour
309 × 457 (12^{13}/$_{16}$ × 18)
Birmingham Museums and Art Gallery
(31.91)
W406

On his return from Switzerland in 1802 Turner reported to the diarist Joseph Farington that 'the Great fall at Schaffhausen is 80 feet, – the width of the fall about four times and a half greater than its depth. The rocks above the fall are inferior to those above the fall of the Clyde, but the fall itself is much finer' (Farington's *Diary*, Friday, 1 October 1802). Shortly afterwards Turner produced two watercolours of the Falls couched in the contemporary language of the 'Sublime': one (W361) from a viewpoint below the fall emphasising its size and awesome power, the other (W362) from a point closer to but similarly evoking its drama and grandeur.

It is characteristic of Turner's mature approach to landscape topography that now, some thirty years later, the falls should no longer be presented as the chief element of the composition but merely as the backdrop to a scene which is filled with human incident. The view is taken from the northern side of the Rhine facing Laufen Castle. Turner's starting point for the composition was a large but rather slight pencil sketch on grey-prepared paper in the Turner Bequest (TB LXXIX E) dating from the 1802 tour, which records the chief contours of the landscape but has an essentially empty foreground. In the finished watercolour, by contrast, Turner presents the viewer with a rich and lively human narrative which has parallels in the watercolours he was painting about the same time for the series *Picturesque Views in England and Wales* (see cat.nos.14–19). Ruskin, who came to own this watercolour after Turner's death, commented on

3 The Keepsake

London, 1833
Open at engraving opposite p.288 by J.B. Allen after J.M.W. Turner, 'Fall of the Rhine' (R 329, later state)
181 × 223 (7^{1}/$_{8}$ × 8^{3}/$_{4}$)
Dr Jan Piggott

In the late 1820s and the first half of the 1830s, a number of watercolours by Turner were engraved for a newly fashionable type of 'pocket' literature known as 'annuals'. Such books had already been popular in many European countries, especially Germany, since the early eighteenth century. However they rapidly proliferated in Britain in the 1820s, thanks in part to the invention of steel plates which enabled a greater number of impressions of the engraved illustrations to be printed from a plate at correspondingly lower cost.

The pocket books were originally a cross between a diary and a reference book, published in the autumn to be given as Christmas and New Year presents. By the early 1820s, however, their topical content had generally been replaced by a literary and artistic miscellany which did not date, and thus in principle they could be sold at any time throughout the year (although in practice they usually continued to be published in the autumn to catch the Christmas market). The fashion for annuals continued unabated until the early 1840s, when they suffered from new competition in the form of the illustrated weeklies, such as *The Illustrated London News* (see Herrmann 1990, p.164).

Turner contributed designs to a variety of annuals in the 1830s, for example *The Bijou*, *The Amulet*, *Friendship's Offering* and *The Literary Souvenir: or Cabinet of Poetry and Romance*. However the greatest number of his watercolours were engraved for the best-known, most lavish and longest-running annual of them all, *The Keepsake*, which had been launched by the publisher Charles Heath in 1827; seventeen watercolours by Turner were engraved for *The Keepsake* between 1827 and 1837. In most cases Turner's drawings are considerably larger than the engraved illustrations, and it has been suggested that he may have lent designs already to hand (or recycled them from other projects) rather than making new ones specifically for the purpose. There is also evidence in the form of a letter (now untraced) dated 1830 from Turner to the engraver Edward Goodall that the artist was reluctant to provide material for the annuals (see Herrmann 1990, p.165), perhaps because he considered its tone too middlebrow. The relatively large size of Turner's watercolour of the 'Falls of the Rhine at Schaffhausen' (cat.no.2), engraved for the 1833 edition of *The Keepsake*, indicates that it was probably not commissioned specifically for the annual, but its light-

hearted tone is nevertheless in keeping with the spirit of the publication.

The short tales or poems which accompanied the engraved illustrations for *The Keepsake* were, however, usually composed for the purpose. Robert Southey, for example, wrote a sequence of 'Stanzas, Addressed to R. [*sic*] M.W. Turner, Esq. R.A. on his view of the Lago Maggiore from the Town of Arona' (w 730) for the 1829 edition of *The Keepsake*. However the anonymous text accompanying this illustration is strangely at odds with the relaxed atmosphere of Turner's daytime scene. For it describes a moonlight visit to the falls in which the party come upon 'several figures, that might have been taken for evil spirits performing their mystical orgies round great fires'.

An engraving by Léonce Lhuillier after Turner's watercolour of 'The Falls of the Rhine at Schaffhausen' also appeared in an unidentified nineteenth-century guidebook (see Powell 1991, p.15).

Abbotsford sketchbook 1831

4 **Abbotsford, the River Front: The Entrance Hall at Abbotsford**
Pencil
Page size 115 × 184 (4½ × 7¼)
Watermarked: 1828
Turner Bequest; cclxvii ff.68 verso, 69
d26045, 26046

Early in 1831 Robert Cadell, the Edinburgh publisher, persuaded Sir Walter Scott to employ Turner on the illustrations to a new edition of his *Poetical Works*. Cadell arranged the details of the commission, whereby Turner was to contribute twenty-four designs at 25 guineas each (terms 'fully under' what Cadell him-

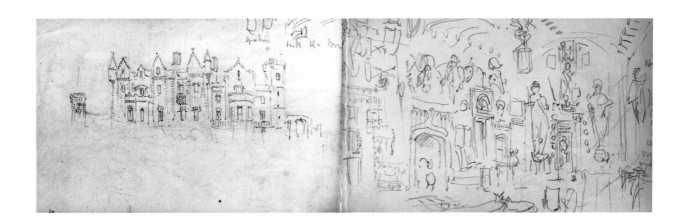

self had expected), for the work was to consist of twelve volumes, each with a frontispiece and title-page vignette. In the first few months of the year, Scott and Cadell corresponded with Turner to advise him on the choice of subjects for illustration. In the meantime Scott expressed his willingness to receive Turner in Scotland 'with all hospitality and conduct him to all the scenes most fit for the minstrelsy' (Finley 1980, p.77).

Scott had not taken to Turner when the two men had met in 1818 in connection with the illustrations to the *Provincial Antiquities of Scotland*, but Turner's visit to Scott's home at Abbotsford in Roxburghshire in the summer of 1831 appears to have been a happy one (see Gage 1980, p.284). Turner used Abbotsford as a base from which to explore the countryside around the Border in search of material for the *Poetical Works*; this sketchbook contains views of Edinburgh, Kelso, Melrose, Dryburgh, Jedburgh and Smailholme as well as of Abbotsford itself.

Abbotsford was created by Scott between 1812 and his death in 1832 to the designs of the architect William Atkinson. It was built on the site of a farmhouse which Scott renamed Abbotsford since the land had belonged in medieval days to Melrose Abbey, and there was a ford over the river Tweed by the house. The view by Turner seen here is the riverside view, and shows how Scott had incorporated into the exterior of the building many traditional features from old Scottish buildings such as the crow-stepped gables and distinctive corner turrets.

Turner's sketch of the entrance hall at Abbotsford shows part of Scott's large collection of arms and armour (which remain at the house to this day), the stone fireplace copied from the cloisters of Melrose Abbey, and the oak panelling from Dunfermline Abbey with which it was fitted out. The hall also contained relics of Waterloo, the head of an elk, the coats of arms of the Border clans, of Walter Scott's ancestors and of his friends; and a cast of the skull of the celebrated Scottish hero Robert the Bruce (1274–1329) (see Wainwright 1989, p.204).

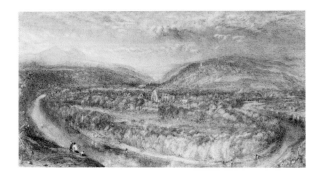

5 **Dryburgh Abbey** *c.*1832
Watercolour
79 × 149 ($3^{1}/_{8}$ × $5^{7}/_{8}$)
N05241
W 1078

Turner's illustrations to Scott's *Poetical Works* have been regarded as some of the most personal he ever conceived. On the one hand they are autobiographical in so far as they record, and often contain specific allusions to, the circumstances of Turner's visit to Scotland in 1831. In addition, as illustrations depicting localities connected with Scott's life or referred to in his poetry and thus intimately associated with him, the illustrations also have a strongly biographical flavour.

This watercolour is no exception, for Scott's family held the right of burial at Dryburgh Abbey. Indeed, before Turner's visit to Scotland, Scott had written to Cadell suggesting that an illustration of the aisle or mausoleum of Dryburgh Abbey be considered for the 'Poetry', but the publisher firmly rejected the proposal on the grounds that he would not admit of 'the Mortality of the Author of the Lay'. It was probably in response to Cadell's protest against using the site of Scott's future grave that Turner settled on a distant view of the abbey from the opposite bank of the encircling Tweed (see Holcomb 1971, p.394 and Finley 1972, p.370).

The watercolour is a synthesis of three slight double-page studies of the abbey from a distance made by Turner in the *Abbotsford* sketchbook when on a day trip to the site from Scott's house in company with Robert Cadell (TB CCLXVII ff.8 verso, 9, 70 verso, 71 and 71 verso, 72; see cat.no.4); the artist also made a number of sketches of the abbey from close to. The watercolour was engraved by William Miller in 1833 and published in 1834 as a frontispiece to volume five of the *Poetical Works*. By then the illustration had taken on a commemorative flavour, for Scott – already unwell at the time of Turner's visit in 1831 – had died in 1832.

Turner was fond of showing meandering rivers from high viewpoints. An example of another watercolour which employs a similar compositional approach is 'Château Gaillard' (see cat.no.32).

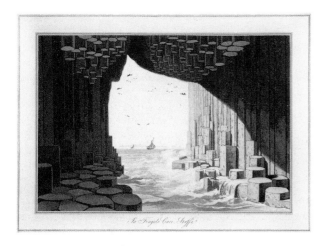

WILLIAM DANIELL (1769–1837)

6 **In Fingal's Cave, Staffa** [first published 1817]
for *A Voyage Round Great Britain* (1814–25)
Aquatint engraving, modern impression printed in 1978–9 by Editions Alecto in association with the Tate Gallery; 164 × 241 (6⁷/₁₆ × 9¹/₂) on wove paper 320 × 390 (12⁵/₈ × 15⁵/₁₆); plate-mark 225 × 303 (8⁷/₈ × 11¹⁵/₁₆)
Engraved inscriptions: '*In Fingals Cave,
Staffa. / Drawn & Engraved by Will ᵐ
Daniell. / Published by Mess.ʳˢ Longman & Cᵒ.
Paternoster Row, & W. Daniell, / 9 Cleveland Street,
Fitzroy Square London, – 21*' below image at centre
T02796

William Daniell's *A Voyage Round Great Britain*, issued in eight volumes between 1814 and 1825, was the most ambitious of the many topographical publications which were produced in England during the early years of the nineteenth century. That Turner himself would have known of the *Voyage* there can be little doubt. For during almost exactly the same period as its plates appeared, W.B. Cooke was publishing, in parts, a series entitled *Picturesque Views on the Southern Coast of England* with line-engravings after watercolours by Turner. These two series were amongst the first of their type to concentrate exclusively on the British coastline, and may indeed have been conceived in direct rivalry with each other. Furthermore it is known that Turner greatly admired Daniell's skill as an engraver (John Pye, *Notes and Memoranda*, London 1879).

There were, altogether, 308 aquatint illustrations to the *Voyage*, accompanied by a lengthy descriptive text written partly by Richard Ayton, but mostly by Daniell himself. The plates were originally printed with two or three base colours – such as a sepia for the foregrounds and a warm grey for distances, perhaps supplemented by a cooler blue-grey for the skies – and were then hand-coloured. Longmans acted as publisher, and indeed many of their account books still survive which contain detailed records of the production of the series. When the Tate Gallery acquired all 306 of the surviving plates for the *Voyage* in 1979 (see *Tate Gallery: Illustrated Catalogue of Acquisitions* 1978–80, pp.15–22), the Tate Gallery Publications Department published a final, limited edition from the plates in association with Editions Alecto. The impression catalogued here is from this recent edition; and like all the other impressions taken from the plates at that time, it was deliberately left uncoloured, so that the delicate tones of Daniell's aquatinting could be fully appreciated.

Daniell's aquatint of Fingal's Cave was first published on 1 July 1817, and appeared in volume three which was dedicated on publication in 1818 'To Walter Scott'. In the dedication, Daniell thanks Scott for 'the many acts of kindness and hospitality which cheered my voyage along the western coast and isles of Scotland' and acknowledges 'the great benefit' he had received 'respecting a region which you [Scott] had recently explored with a poet's eye, and which your genius has rescued from obscurity'. The plates of the western seaboard and islands of Scotland which were included in this third volume are generally regarded as some of the finest and most original in the whole series. The nine aquatints of the island of Staffa, indeed, four of which were of Fingal's Cave, were issued separately in oblong folio in 1818, thanks no doubt to their great popularity (see T. Sutton, *The Daniells: Artists and Travellers*, 1954, no.29, p.172). The numerals '–21' which appear on the publication line of this impression, in a position normally occupied by the year of publication, indicate that it was the twenty-first print in a group of about forty of the Scottish subjects from the *Voyage* which were also issued separately later in the nineteenth century.

For a comparison between Daniell's and Turner's compositions of 'Fingal's Cave' and a fuller discussion of the cave itself, see cat.no.7.

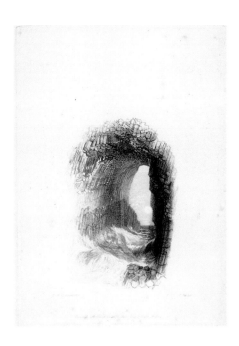

EDWARD GOODALL (1795–1870) AFTER
J.M.W. TURNER

7 **Fingal's Cave, Staffa** 1834
for Walter Scott's *Poetical Works*, vol.x
Line-engraving, vignette, first published state
(R512): approx. 122 × 83 (4¹³/₁₆ × 3¼) on india
paper laid on wove paper 436 × 300 (17¹³/₁₆ ×
11¹³/₁₆); plate-mark 210 × 150 (8¼ × 5⁷/₈)
Engraved inscriptions: '*J M.W. Turner, R.A.*'
below image bottom left, '*Edinburgh, 1834, Robert
Cadell, & Moon, Boys & Graves, London.*' below
image at centre
T04958

After staying with Scott at Abbotsford and making sketching forays in the Border country in search of material for the *Poetical Works* (see cat.nos.4–5), Turner returned briefly to Edinburgh in the summer of 1831 before setting out to explore the more spectacular scenery of the North of Scotland and the West Coast: his tour embraced amongst other sites Stirling, Loch Lomond and Glasgow, Fort William, Inverness and Elgin, and Oban, Staffa and Skye. His visit to the island of Staffa on the steamer the *Maid of Morven* was commemorated in an oil, 'Staffa, Fingal's Cave' (B&J 347; fig.1 on p.12) painted the following year in which he showed the boat valiantly steaming against the wind as it was leaving the island, with the setting sun in the distance.

Turner's journey to Staffa was described in a letter he wrote in 1845 to the New York book collector, historian and philanthropist James Lenox who had purchased the painting that year: 'a strong wind and

head sea prevented us making Staffa until too late to go on to Iona. After scrambling over the rocks on the lee side of the island, some got into Fingal's Cave, others would not. It is not very pleasant or safe when the wave rolls right in. One hour was given to meet on the rock we landed on' (Gage 1980, no.288). That Turner was certainly included amongst the more adventurous of the party who went right into the cave can be concluded from the evidence of a number of slight pencil studies of the cave's interior he drew in the *Staffa* sketchbook (TB CCLXXIII ff.28, 28 verso, 29 and 29 verso). Another study of caves in the same sketchbook, f.22, although not certainly of Fingal's Cave, appears to include the distant setting sun which forms such an important feature in the finished design of the subject seen here in the engraving by Edward Goodall.

Fingal's Cave had been accidentally discovered in 1772 by the eminent naturalist Sir Joseph Banks, and the exciting episode was fully publicised shortly afterwards in Thomas Pennant's *A Tour in Scotland, and Voyage to the Hebrides* (1772; second edition 1776) which included long extracts from Banks's journal. The cave, indeed, was to become something of a place of pilgrimage for the generation of the romantic movement, attracted on the one hand by its association with the father of Ossian, Fiuhn Mac Coul (Fingal) and by its stupendous and dramatic basalt columns on the other (see under B&J 347). William Daniell included four illustrations of the cave in *A Voyage Round Great Britain* (see cat.no.6), and the German architect Karl Friedrich Schinkel drew the exterior of the cave on a trip he made to Great Britain in 1826 (Snodin 1991, no.111; see also under cat.no.57).

One of Daniell's four illustrations was taken, like Turner's design, from inside the cave (cat.no.6) a position, as Daniell himself wrote in the accompanying text to his *Voyage*, 'in which the wonder and admiration of the visitants are most strongly excited, and of which the recollection is present to their minds when they attempt to find language to record those feelings.' Since Turner would certainly have known of Daniell's engraving (see under cat.no.6), a comparison between the two is particularly instructive. Both artists show the view looking out to sea from the interior of the cave and make a feature of the basaltic rocks in the foreground. Daniell's is a relatively serene view, with the water lapping gently round the base of the columns inside the cave. The gloom and mystery of the interior of the cave, seen in deep shadow, is contrasted with the daylight view beyond and its obvious signs of life, such as boats and seagulls on the horizon. The image is in fact strongly reminiscent of late eighteenth-century representations of the inte-

rior of grottos, such as those by Joseph Wright of Derby (see J. Egerton, *Wright of Derby*, Tate Gallery 1990, cat.nos.95 – 100).

Turner's image is, by contrast, considerably more dynamic and evocative. The rays of the setting sun flood in and illuminate the interior of the cave with its turbulent waves throwing up spray as they break against the rock. There are no signs of human life. Both in its mood, and with its vortex-like composition evoking a sense of movement and energy, Turner's is a thoroughly romantic image. It was engraved as the title-page vignette to Scott's poem *The Lord of the Isles* which appeared in volume x of the *Poetical Works* (see cat.no.8), and seems best to illustrate those lines from the fourth canto of the poem which Turner appended to his oil of 'Staffa, Fingal's Cave' when he exhibited it at the Royal Academy in 1832, and which the *British Critic* regarded as 'a strain of poetry, clear, simple and sublime':

> – nor of a theme less solemn tells
> That mighty surge that ebbs and swells,
> And still, between each awful pause,
> From the high vault an answer draws.

Perhaps the most obvious difference between the two designs is that whilst Daniell's illustration is enclosed within a rectangular border, Turner's vignette is free to expand and dominate the available space of the title-page (see cat.no.8), and thus to be more closely integrated with the text. Suprisingly, the original watercolour on which the engraving was based (w 1089) was, like all the other vignettes by Turner for this series, surrounded by an ornamental border. With the exception of the design for 'Abbotsford' (w 1093), however, these were not in the end used for the engraved illustrations and there seems little doubt that they would have detracted from the forcefulness of the original conception. Ruskin, however, who owned the watercolour for this engraving in the late nineteenth century, admired 'the wonderful outline drawing of the rich decoration', although he confessed that he had purchased the vignette 'for its geology, there being no other such accurate drawing of basaltic rock' (Ruskin 1878, pp.44 – 5).

The plates for Scott's *Poetical Works* were engraved between 1833 and 1834. Prior to their publication in book form, the engravings were issued in two parts, each containing twelve plates. It seems likely that this impression comes from such a set.

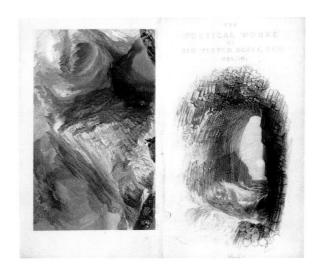

8 **The Poetical Works of Sir Walter Scott, Bar!**
Edinburgh [1834]
Volume x, *The Lord of the Isles*
Open at frontispiece and title-page: 'Loch Coriskin' (R 511, later state) and 'Staffa' (R 512, later state)
159 × 194 (6¼ × 7⅝)
Dr Jan Piggott

The opening displayed here from the tenth volume of Scott's *Poetical Works* demonstrates how the title-page vignettes like 'Staffa' were used in book form. Originally issued individually as quarto-sized proofs on india paper (see cat.no.7), they were subsequently trimmed down well within the plate-mark to form an octavo-sized volume. The vignettes were juxtaposed with an engraved frontispiece after Turner designed according to a more traditional landscape format. The frontispiece seen here is Henry Le Keux's engraving of 'Loch Coriskin' (Coruisk) in the Cuillen Hills on the isle of Skye; the original watercolour by Turner is in the National Gallery of Scotland (w 1088).

The landscape at Coriskin was barren and treacherous but quite spectacular. The geologist John Macculloch (whom Turner had met about 1814) included a long and poetic description of the site in his *Highlands and Western Isles of Scotland* (1824), and wrote that on coming across it suddenly he had 'felt as if transported by some magician into the enchanted wilds of an Arabian Tale' (see Gage 1987, p.220). Turner himself had referred to Loch Coriskin as 'one of the wildest of Nature's landscapes'. In this, one of the most striking of his illustrations to Scott's *Poetical Works*, he well evokes the starkness and desolation of the site so compellingly described by Scott himself in

the fourteenth stanza of the third canto of *The Lord of the Isles*:

> For rarely human eye has known
> A scene so stern as that dread lake,
> With its dark ledge of barren stone.
> Seems that primeval earthquake's sway
> Hath rent a strange and shatter'd way
> Through the rude bosom of the hill,
> And that each naked precipice,
> Sable ravine, and dark abyss,
> Tells of the outrage still.

The two insect-like figures perched on a rock in the foreground of 'Loch Coriskin' are perhaps intended as Turner himself with his guide. Sketching the site, indeed, proved for Turner to be as fraught with personal risk as his trip to Staffa was to be shortly afterwards (see cat.no.7). An editorial footnote accompanying the relevant lines of verse in this volume explains to the reader how, 'but for *one* or *two* tufts of grass [Turner] must have broken his neck, having slipped when trying to attain the best position for taking the view which embellishes this volume.'

Although not a vignette, 'Loch Coriskin' has been seen to contribute to the evolution of the artist's use of the vortex. Adele Holcomb (1970, pp.18–23) has analysed how Turner's distant and elevated viewpoint emphasises the contrast between the height of the central ridge and the depth of the loch below, and how the eye is directed towards a great circular opening beyond the lake revealing unobstructed light in the far distance.

9 **An Old Oak*** *c.*1832
Pencil and watercolour
110 × 133 approx. ($45^5/_{16}$ × $5^1/_4$), vignette;
239 × 307 ($9^3/_8$ × $12^1/_{16}$), sheet size
Turner Bequest; CCLXXX 174
D27691
W 1195

10 **Shipbuilding (An Old Oak Dead)*** *c.*1832
Pencil and watercolour
100 × 140 approx. ($3^{15}/_{16}$ × $5^1/_2$), vignette;
191 × 248 ($7^1/_2$ × $9^3/_4$), sheet size
Turner Bequest; CCLXXX 175
D27692
W 1196

It was for the long poem *Italy*, composed by the banker, collector and connoisseur Samuel Rogers (1763–1855) and published in 1830, that Turner had first produced a sequence of book illustrations using the vignette form. A previous edition of the poem, published between 1822 and 1828, had been very poorly received. But the new 1830 edition with engraved vignettes after Turner was phenomenally successful, 4,000 copies being sold in the first fortnight of publication alone (Holcomb 1971, pp.387–8). The same year, Rogers decided to commission a second set of designs from Turner for a collected edition of his poems other than *Italy*.

As had been the case for the *Italy* illustrations, so for the new edition of Rogers's *Poems* which was published in 1834, Turner agreed to loan out the designs for a fee of 5 guineas each. Thus, unlike for Scott's *Poetical Works* where the illustrations were sold to private collectors once the engravings had been finished, all but one of the thirty-three designs he produced for Rogers's *Poems* are today in the Turner Bequest – alongside the twenty-five he made for *Italy*. Together they are often cited as the finest of all Turner's book illustrations (for *Italy*, see Warrell 1991, cat.nos.52–8).

Turner's illustrations were designed as headpieces or tailpieces to Rogers's *Poems*; these two, for example, were engraved in 1834 by Edward Goodall as illustrations to the poem 'To an Old Oak' which appears between pages 176 and 178 of the 1834 edition. In the design engraved as the headpiece (cat. no.9), the oak is seen standing proudly and robustly on a village green, the focus and symbol of village life

> Then Culture came, and days serene;
> And village-sports, and garlands gay.
> Full many a pathway crossed the green;
> And maids and shepherd-youths were seen
> To celebrate the May

whereas in the illustration produced as a tailpiece (cat.no.10), the oak, now felled, is being wheeled away to the shipyard to be transformed into a ship of the line, 'destined o'er the world to sweep, / Opening new spheres of thought!'

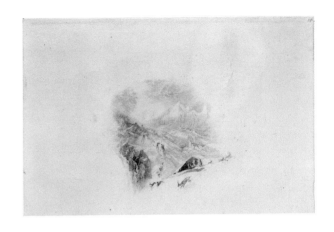

11 **The Alps at Daybreak** *c*.1832
Watercolour
115 × 139 approx. ($4^{1}/_{2}$ × $5^{1}/_{2}$), vignette;
241 × 303 ($9^{1}/_{2}$ × $11^{15}/_{16}$), sheet size
Turner Bequest; CCLXXX 184
D27701
W 1199

In this design, engraved by Edward Goodall as the headpiece to Rogers's poem 'The Alps at Daybreak' (see cat.no.13), Turner brilliantly exploits the potential of the vignette form. The edges of the subject merge with the white of the paper, helping to expand the image ever outwards, and create the impression of a limitless and dazzling snow-filled landscape beyond. Like the 'Hurricane in the Desert' (cat. no.12), the design is based on a vortex of light which forms a conical field with the sun at the centre, and Turner's deliberate elimination of a horizon deprives the image of any stabilising element.

The positioning of the chamois at the lower edge of the design, where they seem to intrude on the viewer's space, not only supplies an additional dynamic ingredient, but also helps to integrate the design with the text (see cat.no.13). Nevertheless, the chamois are an important narrative element in the poem itself:

> The sun-beams streak the azure skies,
> And line with light the mountain's brow:
> With hounds and horns the hunters rise,
> And chase the roebuck thro' the snow.

The chamois are said to have caused Turner some trouble, and to have been completely redrawn by Goodall when translating the design into engraved form (see Rawlinson 1908, p.lii).

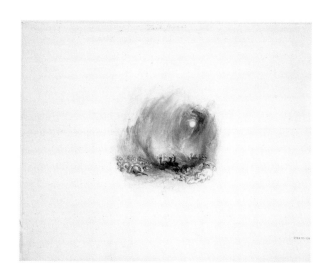

almost exactly square in format. In the same way as that oil was paired by the artist with a picture which takes as its theme the creative power of light, 'Light and Colour (Goethe's Theory) – The Morning after the Deluge' (Tate Gallery; B & J 405), so also has this watercolour been seen as a pendant to the more positive and radiant image, 'The Alps at Daybreak' (Holcomb 1970, p.23). Nevertheless, these two illustrations to Rogers's poetry do not function as pendants in the text; in fact they do not even illustrate the same poem.

12 **A Hurricane in the Desert (The Simoom)**

c.1832
Watercolour
127 × 127 approx. (5 × 5), vignette;
244 × 305 (9⅝ × 12), sheet size
Turner Bequest; CCLXXX 195
D27712
W 1189

This design was engraved by Edward Goodall as an illustration to Rogers's poem 'Human Life'. It appeared on page 94 of the 1834 edition of his *Poems* accompanying the following lines:

> Or some great Caravan, from well to well
> Winding as darkness on the desert fell,
> In their long march, such as the Prophet bids,
> To Mecca from the Land of Pyramids,
> And in an instant lost – a hollow wave
> Of burning sand their everlasting grave!

Caught in the gathering eddies of a devastating sandstorm, a rider is about to be thrown from his horse in the middle distance, the bodies of men and beasts strewn dead and dying in the foreground.

The watercolour is an impressive example of Turner's ability to condense very powerfully so much information into a very small area. The use of a vortex, which as in 'The Alps at Daybreak' was strengthened during the course of engraving (see cat.no.13), can often be associated with images of destruction in Turner's work. It had first been used by the artist in such a context in the oil painting of 1812, 'Snow Storm: Hannibal and his Army Crossing the Alps' (Tate Gallery; B & J 126), and it was to be adopted by him again over a decade later in 'Shade and Darkness: The Evening of the Deluge', 1843 (Tate Gallery; B & J 404) which, like this watercolour, is

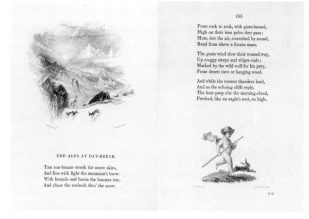

13 **Rogers's 'Poems'**

London, 1834
Open at pp.192–3: 'The Alps at Daybreak', line-engraving by Edward Goodall after Turner
(R 395, fourth state)
197 × 260 (7¾ × 10¼)
Lib. 07668

Twenty-six of the thirty-three illustrations by Turner for Rogers's *Poems* were engraved by Edward Goodall, one of the ablest and most sensitive of all the interpreters of Turner's work. Thanks to the appearance in 1902 of the *Reminiscences of Frederick Goodall RA* (the engraver's son) much important information as to how Turner worked with his engravers has been passed down to us. Furthermore Frederick Goodall explained to W.G. Rawlinson, the cataloguer of Turner's engraved work, that 'in his youth he was accustomed to take his father's trial proofs backwards and forwards to Turner for his criticism' (quoted Rawlinson 1908, p.lii). It was presumably during the course of correcting Goodall's proofs for this illustration that Turner ensured that the tonal contrasts of the design were sharpened and its vortical structure

tightened, as he was similarly to do for Goodall's engraving of the 'Hurricane in the Desert' (see Holcomb 1970, p.24).

In the lettering of this print, the word 'proof' has been added after the artist's name, indicating that this volume must be one of the octavo 'proof editions' which Rawlinson recorded as being published in 1834 (1913, p.239). As for the plate itself, Rawlinson wrote that 'nothing in engraving finer than this small plate ever has been, or ever will be produced' (ibid., p.244).

The tailpiece to this poem is an engraving of a putto with a hare by William Finden after Thomas Stothard. An earlier edition of Rogers's *Poems* had been published in 1827 with woodcut illustrations after Stothard similar in vein to this example. When planning his ideas for the new edition of the *Poems*, Turner annotated a copy of this 1827 edition with his own small pencil sketches; the volume still survives in the Turner Bequest (TBCCCLXVI; see Lyles and Perkins 1989, cat.no.69).

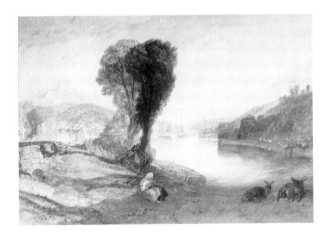

14 **Trematon Castle, Cornwall*** *c.*1829
 Watercolour and bodycolour with scratching out
 280 × 407 (11 × 16)
 Private Collection
 W 822

The most ambitious of all the engraving projects that Turner became involved with during the 1820s and 1830s was *Picturesque Views in England and Wales*. The project was the idea of the engraver Charles Heath, who from the 1820s began to devote his energies to publishing; besides *England and Wales*, for example, which appeared in parts between 1827 and 1838, in the early 1830s Heath also launched a number of popular illustrated annuals such as *The Keepsake* and

The Rivers of France (see cat.nos.3 and 27–36), for which Turner was also engaged to make designs.

By the end of the 1820s seven parts of *England and Wales* had already appeared comprising twenty-eight plates, for the engravings were issued four to each part. In 1830 alone three more parts appeared, the engraving by Richard Wallis after this watercolour (R 246) being issued in part ten that year. The parts continued to be issued at fairly regular intervals throughout most of the 1830s, even though the series saw a tortuous number of changes and realignments in the co-publishers who were prepared to finance the venture with Heath. Longmans, for example, who already had a large share in Heath's other enterprises such as *The Keepsake* and *The Rivers of France*, became co-publishers in 1835. It was Longmans who decided to terminate publication in 1838 after only ninety-six of the anticipated 120 plates had appeared; and these they bound up for sale into two volumes of forty-eight plates each.

Unlike for previous engraved series, Turner himself selected the subjects for *England and Wales*, and they fall into a wide range of categories covering almost every aspect of his range as a landscape painter – coastal subjects, urban and industrial views (see cat.no.16), English pastoral scenes, and views of cathedrals, abbeys or castles such as this view of Trematon. Many of the subjects were adapted by Turner from extant drawings; this watercolour, for example, is based on sketches in the *Plymouth, Hamoaze* sketchbook (TBCXXXI 37, 38, 43) used by Turner on a trip to the West Country in 1813. Others, such as 'Dudley' (cat.no.16), were based on new material gathered by the artist on a tour to the Midlands in 1830 undertaken especially for the project.

In this watercolour the viewer is looking towards the estuary of St Germans river, with Trematon Castle itself bathed in early morning light to the far left (see Shanes 1990, p.200). The mood is one of serenity and calm. The whole of the distance is a masterpiece of suffused dawn haze, whilst in the centre foreground beams of light (indicated where Turner has scratched out areas of colour) cast their rays through the trees illuminating an area of yellow banking to the left; in the foreground shade sits a young girl sewing, the indigo of the fabric draped over her lap (painted by Turner in bodycolour) providing a bold splash of complementary colour.

Trematon was one of thirty-five watercolours for *England and Wales* which were exhibited by Heath in June 1829 at the Egyptian Hall, Piccadilly, in an attempt to promote the series; it was included in the accompanying catalogue as item number fifteen, misspelt as 'Tamerton'. By 1835 the watercolour was

owned by the collector Benjamin Godfrey Windus (see cat.no.15), who auctioned it in London in 1857 ten years before he died. Thereafter the watercolour disappeared completely from public view until it was lent to an exhibition at Falmouth Art Gallery in 1989. This exhibition is the occasion of its first showing in London for 135 years.

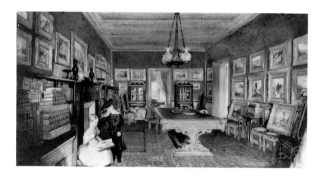

JOHN SCARLETT DAVIS (1804–1844)

15 **The Library at Tottenham, the Seat of B.G. Windus, Esq.*** 1835
Watercolour with stopping out, heightened with gum arabic
299 × 557 (11¾ × 21¹⁵/₁₆)
Trustees of the British Museum (1984-1-21-9)

In a discussion of the artist's 'many very liberal patrons', Turner's obituarist for *The Gentleman's Magazine* wrote in February 1852 that 'it is at Mr. Windus's on Tottenham-green that Turner is on his throne. There he may be studied, understood, and admired – not in half-a-dozen or twenty instances, but in scores upon scores of choice examples'.

Benjamin Godfrey Windus (1790–1867) came from a family of coach-makers with an office in the City. He began to collect watercolours by Turner from about 1820, and by the late 1830s had amassed about two hundred (see L. Stainton, *British Landscape Watercolours 1600–1860*, 1985, cat.no.169). He also accumulated a fine collection of drawings by the Scottish artist David Wilkie and was later a supporter of the Pre-Raphaelites. Ruskin wrote that 'Mr Windus . . . gave an open day each week, and to me the run of his rooms at any time', and added that the advantage of being able to see all the Turner watercolours collected together at his house 'was, to the

general student, inestimable, and, for me, the means of writing "Modern Painters"' (*Praeterita*, vol.II, chap.I, 11).

Some of the very finest of Windus's Turner watercolours were hung in the library, a room he had added to his house in Tottenham Green, north of London, in the early 1830s – just a short while, in fact, before he commissioned this watercolour from the young artist Scarlett Davis in 1835. Finished watercolours by Turner predominated in his collection, and these included thirty-six subjects for *Picturesque Views in England and Wales*. A group of these can be seen in Davis's watercolour hanging on the wall to the right, this side of the doorway. Hanging second from the left in the middle row is 'Trematon' (cat.no.14), while to its left is 'Great Yarmouth' (w 810) and to its right are 'Kilgarren' (w 806) and 'Saltash' (w 794); on the row above, left to right, are 'Okehampton' (w 802), 'Richmond' (w 808), 'Fowey' (w 801) and 'Exeter' (w 807); propped up on the chair below are, to the left, 'Alnwick Castle' (w 818) and, to the right, the only watercolour of this group not from *England and Wales*, the 'Palace of La Belle Gabrielle' (w 1049) which was engraved for *The Keepsake* in 1834 (see cat.no.3). Some time after this watercolour was painted, Windus also acquired 'The Falls of the Rhine at Schaffhausen' (cat.no.2).

Davis's watercolour is, then, a vital record of the contents of an important collection of Turner watercolours in the mid-1830s. But it is also an invaluable document of the appearance of such a collection, for it shows how Turner's watercolours were elaborately framed, according to the taste of the time, and hung against a dark red background not dissimilar to that adopted by Turner himself for his own gallery in Queen Anne Street. Turner is known to have admired Davis's watercolour, for the latter recorded in a letter to a friend that the artist had 'spoken in the highest terms of it, and that it now hangs in company with fifty of his best works' (Finberg 1961, p.353).

Gage records a comment by the painter and collector James Orrock who claimed to have been informed, 'on unimpeachable authority, that each of the matchless drawings [by Turner] which were painted for Mr Windus of Tottenham, was executed there in a day' (1987, p.173). Ruskin, on the contrary, stated that 'Mr Windus bought all that were made for engravers as soon as the engraver had done with them', (*Praeterita*, see above), and it certainly seems more likely that Windus would have purchased them in this way rather than commissioning Turner to execute them in his house.

The children included in the picture are Mary, Windus's daughter, and Arthur his son.

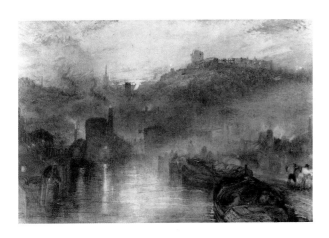

16 **Dudley, Worcestershire*** *c.*1832
Watercolour and bodycolour
288 × 430 (11⅜ × 16¹⁵/₁₆)
Trustees of the National Museums and Galleries on
Merseyside (Lady Lever Art Gallery)
w 858

Dudley's association with the production of iron reaches as far back as the Middle Ages, and by Turner's day the whole of the surrounding area known as the Black Country was conspicuous for its dense concentration of heavy industry. Dudley's industries had been served since the eighteenth century by a canal system capable of transporting both the necessary raw materials and the finished goods between Birmingham in the east and the river Severn in the west; one mid-Victorian traveller likened its extensive canal network to 'bleeding veins'. Docked at the right of Turner's watercolour is a loaded vessel labelled 'Dudley' carrying hoops of sheet iron, destined for one of the nearby foundries or finishing shops which produced anvils, fenders or other such metal work (Rodner 1988, pp.32–6).

Contemporary descriptions of the town and its surroundings tended to be based on the view obtainable from the hill close to the ruins of Dudley Castle. Turner however chose a vantage point further from the town, at Dudley Port about a mile to the northeast. For it was from this direction that the castle's ruins and the town's two distinctive churches could be evocatively contrasted with the furnaces, chimneys and canal boats of the industrial scene below. And indeed Turner's watercolour brilliantly conjures up the impression of an old West-Midland town caught in the throes of intense technological change.

John Ruskin, who owned this watercolour for a time despite his growing antipathy to industrialism, wrote that it represented 'one of Turner's first expressions of his full understanding of what England was to become', the ruined castle and church spires to him

'emblems of the passing away of the baron and the monk' (Ruskin 1878, p.34). Turner's watercolour, however, conveys no such mood. On the contrary, it betrays that same excitement and fascination for the industrial scene that characterises other work by him in a similar vein, for example the watercolour of 'Shields on the River Tyne' of *c.*1823 (w 732), and the oil painting 'Keelmen Heaving in Coals by Night' (b & j 360) dating from the mid-1830s. In all these representations of industry Turner chooses to set the scene at night, for not only was the glare of furnaces then more vivid, but the warmth of firelight could be contrasted with the coolness of moonlight. Furthermore the nocturnal setting helps to emphasise the intense labour which such industrial activites required. In Turner's watercolour of 'Dudley', for example, the impression is given that humanity never rests as workmen are glimpsed at their chores in the artificial light produced by the various fires associated with manufacturing (Rodner 1988, p.37).

Turner made sketches of Dudley in two of the sketchbooks he took with him on a tour of the Midlands in 1830, the *Birmingham and Coventry* sketchbook (t b c c x l) and the *Kenilworth* sketchbook (see cat.no.20). None of these studies corresponds exactly with the watercolour, although a double-page spread in the *Kenilworth* sketchbook (ff.65 verso, 66) shows a similar view of the town. The watercolour was one of sixty-six subjects from *England and Wales* to be shown at a special exhibition held by the then publishers for the series, Moon, Boys and Graves, in their gallery in Pall Mall in 1833 to promote the series; a similar exercise had been adopted by Charles Heath at the Egyptian Hall four years previously (see cat.no.14). It was engraved by Robert Wallis for part x i x of the series which was issued in 1835 (r 282).

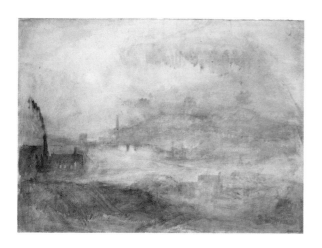

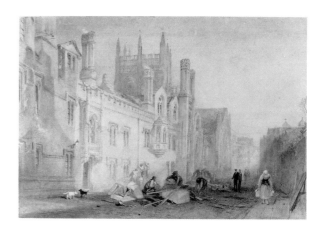

17 Colour Study: An Industrial Town at Sunset, ? Dudley* *c.*1830–2
Watercolour
244 × 483 (9⅝ × 19)
Turner Bequest; CCLXIII 128
D25250

18 Merton College, Oxford* *c.*1835–8
Watercolour with some scraping out
294 × 432 (11⁹⁄₁₆ × 17)
Watermarked: J WHATMAN / TURKEY MILL /1825
Turner Bequest; CCLXIII 349
D25472
W 887

Large colour studies such as this one are plentiful in the Turner Bequest, and cover every phase of the artist's working life. A large proportion of them seem to be connected with the series *Picturesque Views in England and Wales*. Their general function is to investigate the interrelationship of basic blocks of colour. Often known as 'colour beginnings', their relation to finished designs can broadly be defined as threefold: at times they are clearly preparatory to identifiable subjects; more often than not, as in this example and in the case of cat.nos.22–6 below, they supply evidence of subjects that were not developed any further; and at other times they are too generalised to afford any clues as to their subjects at all.

The subject of this colour study has not been firmly identified. Although it shows an industrial scene similar to 'Dudley' (cat.no.16) – and indeed it shares a number of features with that watercolour such as the smoke and haze produced by the fires of industry (see Wilton 1980, p.168) – nevertheless it is clearly not a study for it. It may be an abandoned version of the subject seen from a different viewpoint, although it does not correspond with any of the pencil studies of Dudley made by Turner on his Midland tour in 1830 (see under cat.no.16). Or it may show a different town somewhere else in the Midlands. Wherever its exact location, it clearly shares with the watercolour of Dudley an optimistic view of industrial activity; indeed it has been described as 'a poem of almost lyric enchantment' (Wilton, ibid.).

Full-scale finished watercolours such as this one are a rarity in the Turner Bequest, since they were usually made by the artist for engraving projects and thus sold to the publisher (and subsequently to private collectors) according to the terms of the original commission (see also under cat.no.15). Although this watercolour was never engraved, its size, handling and subject all suggest that it was made by Turner for the series *Picturesque Views in England and Wales*.

The watercolour is based on a detailed pencil study in the *Oxford* sketchbook (TB CCLXXXV f.23 verso; see cat.no.21) which is thought to have been used on Turner's visit to the city in 1834 (another sketchbook, the *Oxford and Bruges* sketchbook, TB CCLXXXVI, was certainly used in Oxford at that time; see Powell 1991, p.46). If by including stone-masons in the watercolour (they are not evident in the preliminary pencil study) Turner is referring to the building work which took place on the Merton Street facade of the college between 1836 and 1838 (see Shanes 1990, p.259), then the watercolour may well date from as late as 1838 when *England and Wales* was brought prematurely to a close, which might explain why the watercolour never came to be engraved. Another view of Oxford, of 'Christ Church College' (W 853), had been engraved for the series in 1832, but this would not necessarily have precluded a second version of the city for the series.

Turner presents the view of Merton College in rich evening light. One of the builders pauses at his work to catch the eye of a passing milkmaid, who returns his glance; such well-observed anecdotes of human

behaviour are characteristic of the series. The inclusion of two dogs in playful juxtaposition is a recurring Turnerian motif (see also cat.no.36).

Life Class sketchbook, no.1 ?c.1832

19 **A Man Talking to an Oyster-Seller**
Pencil
Inscribed: 'The Bivalve Courtship'
86 × 111 (3³⁄₈ × 4³⁄₈)
Turner Bequest; CCLXXIXa f.7
D27378

This amusing and tender scene is a good example of the sort of everyday episode Turner was fond of recording in his sketchbooks, and which inform the content of his mature watercolours like those for *England and Wales* so rich in human anecdote (see cat. no.18).

Turner's inscription, 'The Bivalve Courtship', almost certainly reveals his awareness of the recent discoveries of Sir Anthony Carlisle, Professor of Anatomy at the Royal Academy between 1808 and 1824, and Turner's doctor in the artist's later years. During the early nineteenth century bivalves, that is molluscs such as oysters with hinged double shells, had been regarded as androgynous. But in 1826 Carlisle delivered a remarkable lecture in which he proved, by dissecting an oyster, that just as for worms and snails so also for oysters 'the mutual intercourse of two individuals is required' (Gage 1987, pp.217–18).

Kenilworth sketchbook 1830

20 **Two Views of Oxford: the High Street and Magdalen College from the Bridge**
Pencil
Page size 112 × 190 (4¹⁄₂ × 7¹⁄₂)
Turner Bequest; CCXXXVIII ff.1 verso, 2
D21976, 21977

This is one of the sketchbooks which Turner took with him on a tour he made to the Midlands in 1830 in search of material for the series *Picturesque Views in England and Wales*. As well as these studies of Oxford (and the sketchbook also contains on page 1 a study of Christ Church College which appears to have been adapted for the finished watercolour of the subject engraved for the series in 1832, see under cat.no.18), there are sketches of Dudley (cat.nos. 16–17), Kenilworth, Tamworth, Lichfield and Virginia Water.

In about 1810 Turner had painted an oil of the High Street in Oxford (B & J 102; fig.7, below) for the picture dealer, printseller and frame maker James Wyatt (1774–1853) whose premises (and home) were located at no.115 the High Street. Wyatt had commissioned the picture with a large engraving in mind. The preliminary drawing (TB CXX F), the oil itself, and the engraving made from it in 1812 by Samuel Middiman, John Pye and Charles Heath (R 79) were

the subject of a lengthy correspondence between Turner and Wyatt (see Gage 1980, nos.24–34, 41 and 44–6).

The oil shows the view looking westwards down the High Street towards Carfax from a point close to All Souls College on the right and University College on the left. Three church towers are in evidence: the Gothic spire of St Mary's, the parish church of Oxford, to the right; the Baroque spire of All Saints, designed by Robert Potter, some distance beyond; and the smaller tower of Carfax church which closes the view in the far distance. In this pencil sketch of the High Street, however, also looking westwards, Turner's viewpoint is considerably further back (that is eastwards) along the street (roughly corresponding to what is today the entrance to Queen's Lane); the cupola of Queen's College appears in the right-hand foreground. Now that Turner has moved further eastwards, the tower of Carfax has disappeared from view, whilst the spire of All Souls is just visible in the distance. This sketch has traditionally been regarded as the starting point for all five colour studies of the High Street the artist made some time in the 1820s or 1830s (see cat.nos.22–6) but in fact it corresponds to only two of them (cat.nos.24–5), and even in those Turner chose to omit the spire of All Saints in the distance.

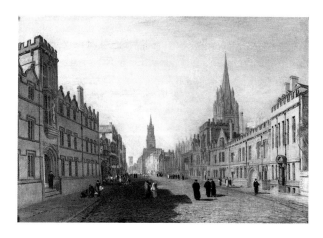

fig.7 'View of the High-Street, Oxford', exh. Turner's Gallery 1810, oil on canvas, 685 × 1003 (27 × 39½) (B & J 102). *The Loyd Collection*

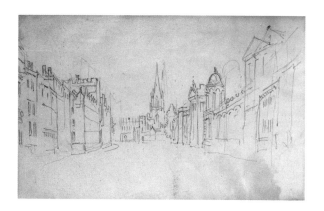

Oxford sketchbook *c.*1834

21 **The High Street, Oxford**
Pencil
Page size 147 × 235 (5¹³/₁₆ × 9¼)
Watermarked: 1828
Turner Bequest; CCLXXXV f.2 verso
D27903

In July 1834 Turner visited Oxford, his chief motive for the trip being to meet Wyatt's successor, James Ryman, who had 'some further engravings of Oxford subjects in contemplation' (Finberg 1961, p.348; see also under cat.nos.18 and 26). It was on that visit that this sketchbook was probably used.

This study of the High Street is taken from slightly further back than the similar sketch Turner had made about four years before (see cat.no.20), so that slightly more of Queen's College has come into view on the right. The spire of All Saints is now out of view, and that of St Mary's is now positioned towards the centre of the composition. One of Turner's colour studies of the High Street (cat.no.26) was taken from roughly this position.

22 **Colour Study: The High Street, Oxford**
?*c.*1820–5
Watercolour
372 × 548 (14⅝ × 21⁹/₁₆)
Turner Bequest; CCLXIII 5
D25127

23 **Colour Study: The High Street, Oxford**
?*c.*1820–5
Watercolour
305 × 485 (12 × 19⅛)
Watermarked: J WHATMAN / 1816
Turner Bequest; CCLXIII 3
D25125

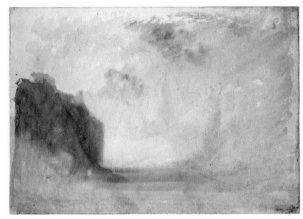

22

25

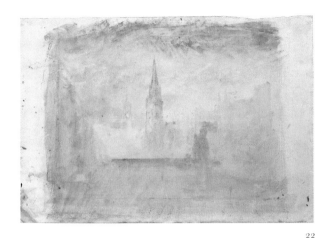

23

26

24

24 **Colour Study: The High Street, Oxford***
 c.1837–9
 Watercolour
 361 × 487 (14³/₁₆ × 19³/₁₆)
 Turner Bequest; CCLXIII 4
 D25126

25 **Colour Study: The High Street, Oxford***
 c.1837–9
 Watercolour
 355 × 515 (14 × 20⁵/₁₆)
 Turner Bequest; CCLXIII 106
 D25228

26 **Colour Study: The High Street, Oxford***
 c.1837–9
 Pencil and watercolour
 382 × 558 (15¹/₁₆ × 22)
 Watermarked: J WHATMAN/1837
 Turner Bequest; CCLXIII 362
 D25485

Some of the 'colour beginnings' in the Turner Bequest (see under cat.no.17) exist as sequences which

show Turner working towards a composition through several experimental schemes. These five watercolours of Oxford High Street have often been seen as just such a group, probably related to a composition Turner planned for inclusion in the series *Picturesque Views in England and Wales*, even if no such subject was actually engraved (see Gage 1987, pp.86–8). In that context they are usually dated to about the early 1830s, for it was at that time that the colour lay-in seems to have been of particular importance to Turner's working practice.

However, it is suggested here that the five watercolours do not necessarily date from the same time, nor were they necessarily made for the same project. Three of them, cat.nos.24–6, seem related to each other in their colour schemes (pinks, purples and blues are common to them all) and in their organisation; and they can be dated to the late 1830s on the evidence of a watermark for 1837 on one of them (cat.no.26). Furthermore, all three are based on viewpoints sketched by Turner in the first half of the decade from positions well east along the High Street (see cat.nos.20–1).

The other two colour studies, however, cat.nos. 22–3, are based on a colder colour range of blues, yellows and greys, and on stylistic grounds appear to belong to an earlier period (cat.no.23 is on paper watermarked 1816). Neither of them can be related to the sketches of the High Street Turner made in the 1830s: cat.no.23 is taken from a point slightly closer towards Carfax than the study in the *Kenilworth* sketchbook (cat.no.20), even if the building on the right is still identifiable as Queen's College; and cat.no.22 is the only one of the entire group to depart from topographical veracity, for it is not possible to see both All Saints and St Mary's from a viewpoint which is at the same time consistent with St Mary's appearing at the centre of the composition. Both may have been adapted from earlier studies, in particular the oil of the High Street the artist made for James Wyatt in 1810 (see under cat.no.20).

It is possible that these two, earlier colour studies of the High Street may indeed be ideas for a composition for *England and Wales* which was never executed. The other three, however, if painted towards the end of the decade, are unlikely to have been intended for that project as well since it was about that time that it was brought to a premature close (see under cat.no.14); in any case 'Merton College' is a more serious contender as a second Oxford subject for the series (see under cat.no.18). Cat.no.26, the largest of all these studies, is almost identical in size to a finished view of 'Oxford, from Boar's Hill' (w889) which Turner painted in the late 1830s for Wyatt's

successor, James Ryman, commissioned for the purpose of an engraving which was made from the drawing soon afterwards (R651). It may be that, along with its two related colour studies cat.nos.24–5, cat.no.26 is a preliminary design for a second watercolour which Wyatt commissioned to be engraved as a pair to 'Oxford, from Boar's Hill'; the print after Turner's oil of Oxford High Street (R79) had after all been paired with a more distant view of the city from the Abingdon Road (R80) over twenty years before.

There is a further colour beginning of Oxford High Street in the Turner Bequest (TBCCCLXV 26) seen from the opposite direction (repr. Wilton 1988, no.42). In colour and scale it is clearly related to cat.nos.24–6.

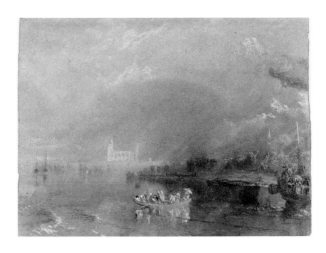

27 **Jumièges** *c*.1832
Bodycolour on blue paper
140 × 190 (5½ × 7½)
Turner Bequest; CCLIX 131
D24696
W961

Between 1833 and 1835, three handsome volumes appeared on the market containing steel-engraved illustrations of French river scenery from designs by Turner. Produced 'under the superintendence of Charles Heath', the three volumes were published by Longmans (with whom Heath also collaborated on *The Keepsake* and *Picturesque Views in England and Wales*, see cat.nos.3 and 14) under the general title of *Turner's Annual Tour*: the first volume, dated 1833, was subtitled *Wanderings by the Loire*, whilst the second and third volumes, bearing the publication dates 1834 and

1835, were devoted to *Wanderings by the Seine*. Turner's designs for the Loire volume were painted in the late 1820s and, once owned by Ruskin, are now mostly in the Ashmolean Museum in Oxford; those for the Seine volumes, however, probably executed about 1832 after a tour to Paris and the Seine that year (see cat.no.31), are mostly in the Turner Bequest (w 951–90). The text for the three volumes (usually referred to as *The Rivers of France*) was written by the popular author Leitch Ritchie whom Heath had already employed in 1832 on a *Picturesque Annual* subtitled *Travelling Sketches in the North of Italy, the Tyrol and on the Rhine*, and who was to contribute to many other annuals during this period (Herrmann 1990, p.167).

All Turner's designs for *The Rivers of France* were, like this example, made in bodycolour on small sheets of blue paper, and resemble the sketches he had made at Petworth in the late 1820s. However, those sketches were essentially personal and informal in character, like most of the artist's work in bodycolour. The designs for *The Rivers of France*, by contrast, are unique in Turner's work in being produced in that medium as 'finished' works for the engraver, and they are in fact amongst the least 'linear' and least detailed of any of his drawings destined for translation into engraved form. Details hardly legible in the original designs but subsequently clarified in the engraved illustrations are likely to have been corrected by Turner at proof stage. In the engraving by J.C. Armytage made from this design for the first of the two Seine volumes in 1834 (R 463), for example, the distant ruins of the great Benedictine abbey of Jumièges are brought into much crisper focus.

This illustration is based on a pencil drawing in the *Tancarville and Lillebonne* sketchbook (TB CCLIII f.59 verso), in which even the boat and passengers in the foreground were included. It has been suggested that the original sketch (and others of Jumièges in this sketchbook and in the *Seine and Paris* sketchbook, see Alfrey 1982, p.344) was made as Turner himself travelled past the abbey in a boat. He depicts his fellow travellers enthusiastically enjoying the sights (one of the figures in the foreground boat is pointing towards the abbey with a stick), although some of them are already taking shelter under their umbrellas against the impending storm.

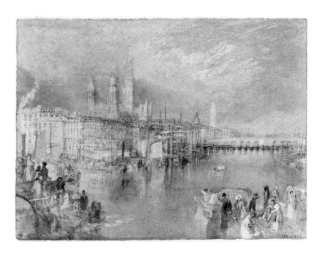

28 **Rouen, Looking up the Seine** *c.*1832
Bodycolour, with some pen, on blue paper
141 × 192 (5^9/₁₆ × 7^9/₁₆)
Turner Bequest; CCLIX 107
D24672
W 963

Much of the material which Turner relied on when making his designs for *The Rivers of France* was gathered on a visit to the Seine in 1832 (see cat.no.31), but he also drew inspiration from two earlier tours to the area in 1821 and 1829. For this illustration of Rouen, for example, it is clear that Turner referred to the very detailed studies he had made of the cathedral in the *Dieppe, Rouen and Paris* sketchbook used in 1821 (TB CCLVIII; see for example ff.6 verso and 7, repr. Warrell 1991, cat.no.2). Turner still shows the old spire of the central tower of the cathedral, which had been destroyed by fire in 1822; construction on the new cast iron spire which survives to this day had begun in 1827, five years before this design was made. The view also owes something to the sketches of Rouen Turner had made on his later visits to the city (in the *Tancarville and Lillebonne*, the *Rouen* and the *Seine and Paris* sketchbooks, TB CCLIII, CCLV, CCLIV). For these show more interest in the distant view, with the cathedral often seen, as here, in the middle distance and related to a changing foreground of buildings, boats and water (Alfrey 1982, p.415).

In the accompanying text to this illustration, Ritchie describes the other churches which appear in the distance of this view, the 'stunted and shapeless tower of Saint Maclou' and the 'tall, graceful and beautiful' profile of Saint Ouen beyond; he also draws attention to the 'new stone bridge', beyond the bridge of boats, which is one of the chief compositional elements in another illustration of the city made by Turner for the series, 'Rouen, Looking down the Seine' (w 964).

indeed had been a feature of Turner's own work in earlier years. But they are less characteristic of his views for *The Rivers of France* in which he generally preferred the distant prospect, and especially a panorama (see cat.no.32).

Even though this design is based on a very detailed pencil drawing in the *Dieppe, Rouen and Paris* sketchbook of 1821 (TB CCLVIII f.22; see also under cat. no.28), Turner's finished design reveals less concern for the intricate detail of the cathedral's facade than for the play of light across its surface, anticipating Monet's studies of the same feature some sixty years later. The original bodycolour drawing for this engraving is in the Turner Bequest (TB CCLIX 109; W 965). Turner made another view of the cathedral's west front, as seen through the arches of the Portail des Libraires rather than from the market square as here, which was perhaps intended as an alternative design for the series (TB CCLIX 149).

29 Turner's Annual Tour: Wanderings by the Seine, from Rouen to the Source
By Leitch Ritchie, Esq ... with Twenty Engravings from Drawings by J.M.W. Turner, Esq. R.A.
London, 1834
Open at pp.152–3: 'Rouen Cathedral' (R 467, fifth state)
207 × 247 (8⅛ × 9¾)
Lib.1043A

The title to the two volumes of *Wanderings by the Seine* defined the boundaries of the tour as 'from Rouen to the Source'. But although the reader is indeed taken on a journey up river, the tour and the engraved illustrations actually commence at Le Havre, where the Seine meets the sea. Nevertheless Rouen, as the ancient capital of the duchy of Normandy, was clearly one of the tour's highlights, and no less than four illustrations of the city by Turner were engraved for the series.

One of the illustrations of Rouen shown here in the engraving by Thomas Higham (R 467), bound into a copy of the first edition of *Wanderings by the Seine*, was a view of the west front of the cathedral seen from close to. Such enclosed vistas were favoured by other topographers working on the Continent during the same period, such as Samuel Prout (1783–1852) and

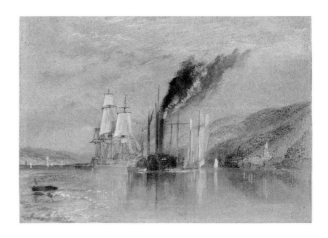

30 Between Quilleboeuf and Villequier c.1832
Watercolour and bodycolour on blue paper
138 × 190 (5⁷⁄₁₆ × 7½)
Turner Bequest; CCLIX 104
D24669
W 968

Studies of steamboats on the Seine occur in both the *Tancarville and Lillebonne* sketchbook (TB CCLIII f.55

verso) and the *Seine and Paris* sketchbook (TB CCLIV f.80). Indeed the steamboat recurs often in Turner's work, and is a symbol of modern life. Its juxtaposition here with a sailing vessel serves to point out the contrast between the old and the new, a contrast Turner was later to make more insistent in one of his most celebrated oils, 'The Fighting "Temeraire"' of 1839 (National Gallery, B & J 377; fig.5 on p.19). In this period steam passenger-boats were gradually being introduced onto Europe's waterways, helping promote the new tourist industry of the mid-nineteenth century (Powell 1991, pp.19–20). But the steamboat shown here is clearly a commercial vessel. If Turner often shows the Seine as a scenic and historic route of interest to the nineteenth-century traveller (see cat.no.27), here we are reminded that the river was also a busy commercial thoroughfare.

Seine and Paris sketchbook 1832

31 **Two studies of Château Gaillard**
 Pencil
 Page size 174 × 117 ($6^{13}/_{16}$ × $4^5/_8$)
 Turner Bequest; CCLIV ff.54 verso, 55
 D23988, 23989

Turner's trip to France in 1832 was partly prompted by the need to gather material for the illustrations commissioned by Cadell for Walter Scott's *Life of Napoleon* (see cat.no.39). But it was also on this tour that he gathered much of his material for *The Rivers of France*. Most of the subjects published in the second part of the *Wanderings by the Seine*, 1835, were based on studies made in this sketchbook or in the *Paris and Environs* sketchbook (cat.no.39).

A whole section of this sketchbook, for example, is filled with slight and rapid sketches of Château Gail-

lard, and reveal Turner less concerned with amassing information than with examining the various pictorial possibilities of the site. The study on folio 55, although only one of the compositional ideas he had begun to evolve in front of the motif, was adapted into one of the finest illustrations he made for the series (cat.no.32), engraved for the 1835 volume of *Wanderings by the Seine* by J. Smith. The study opposite is one of a number in the sketchbook taken from a lower viewpoint, emphasising the castle's position perched high on a rocky cliff; a composition showing the castle from below was engraved as the frontispiece vignette to the same volume (W 971).

32 Château Gaillard, from the East* *c.*1832
Bodycolour, with some pen, on blue paper
141 × 191 (5⁹/₁₆ × 7½)
Turner Bequest; CCLIX 113
D24678
W 972

Château Gaillard was built in the late twelfth century by the famous crusader king, Richard Coeur de Lion, at the time of his wars against Philip Augustus. Originally known as the Rock of Andeli, we are told by Leitch Ritchie in the accompanying text, it was subsequently renamed Château Gaillard thanks to a momentary expostulation by Richard: 'C'est un château gaillard' (the nearest English equivalent is 'insolent'), he cried, presumably referring to its outstanding and defiant position dominating the surrounding area. The castle in fact fell to the French in 1204, but at the beginning of the seventeenth century was still considered one of the most magnificent and complete specimens of military architecture in Europe. It was gradually dismantled, we are told by Ritchie, first by Henri IV and then by Louis XIII, who feared it might fall into enemy hands.

Turner's watercolour of the castle well evokes a sense of its chequered history. The panoramic landscape spread out below reminds one of the domains it once commanded, whilst the ruin of the castle itself in the foreground suggests the forces of inexorable decay (see Alfrey 1982, p.394; and for a comparison with Turner's views of the castles on the Rhine, Meuse and Moselle, see Powell 1991). The double perspective created by the sweeping curve of the Seine below is a particularly bold device.

33 The Lanterne at St Cloud* *c.*1832
Bodycolour on blue paper
140 × 190 (5½ × 7½)
Turner Bequest; CCLIX 132
D24697
W 981

Engraved by J.T. Willmore for the 1835 volume of *Wanderings by the Seine* (R 483), this watercolour is based on a number of pencil studies in the *Seine and Paris* sketchbook (TB CCLIV ff.11 verso, 14 verso, 15 verso, 23 verso and 24; see cat.no.31).

Turner's inclusion of a large group of figures in the scene lends an atmosphere of relaxation and festivity and reflects the reputation of the site as a place of popular resort. Somewhat uncharacteristically for the series, the illustration in this instance bears a close correlation with Ritchie's text which, by turns informative and amusing, is worth quoting here at length. 'On the loftiest part of the park, on an eminence dominating the valley of the Seine', Ritchie writes, 'there is an obelisk constructed in imitation of the monument of Lysicratus at Athens, and called the Lanterne de Demosthène. It is here where the citizens resort in the greatest crowds, to eat, drink, and sing, to loll on the grass, to whisper tales of love, and, in short, to enjoy those to them inestimable blessings of fine weather and open air. It is here where we have often witnessed such scenes as that presented in the engraving, and where ... we have often wished that we could exchange the taciturn, meditative manner of our country for the restless happy buoyancy of the Parisian'.

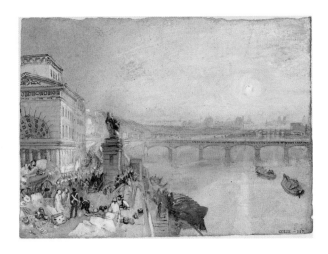

34 Paris: View of the Seine from the Barrière de Passy, with the Louvre in the Distance*
*c.*1832
Bodycolour with some pen on blue paper
143 × 194 (5⅝ × 7⅝)
Turner Bequest; CCLIX 117
D24682
W983

The pace at which Turner leads the reader up river in *Wanderings by the Seine* by means of its illustrations is remarkably well judged. In the first of the two volumes he had introduced the general idea of a river rich in historical associations yet one of the arteries of commerce. Now, in the second volume, as the Seine flows towards Paris, there is a sense that the pace of life itself is quickening and the river becoming busier. The illustration of 'The Lanterne at St Cloud' on the outskirts of the city, with its bustling Parisian crowds (cat.no.33), acts as a foretaste of the noisy urban scenes to come. The series indeed reaches a climax in the five views of Paris included by Turner in the second volume, although there are three further illustrations charting the section of the Seine beyond Paris towards its source (for example, 'Troyes', cat.no.36).

In this, the introductory watercolour to Paris, the reader finds himself poised to enter the city at one of the barrières or pavilions erected in the mid-1780s by the great neo-classical architect Claude Nicolas Ledoux (1736–1806) at the entrances to Paris. Although the title of the engraving after this design by J.T.Willmore (R485) identified the gate as that of Passy, Alfrey points out that it is in fact the Barrière des Bonshommes (1982, p.458). The watercolour is based on a study in the *Paris and Environs* sketchbook (TB CCLVII f.156; see cat.no.39) which includes studies of two more of Ledoux's gates, the Barrière de Trône and – one of the best-known of them all – the Barrière de la Villete in Place Stalingrad.

With its long, deep perspective lines and distant views of the Tuileries, the Louvre and the twin towers of Notre Dame, this watercolour contrasts with the more enclosed views of the city which follow (cat.no.35).

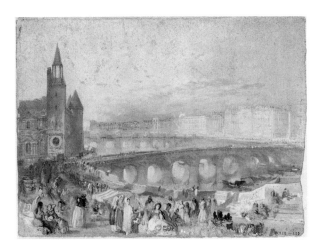

35 Paris: Marché aux Fleurs and Pont-au-Change *c.*1832
Watercolour and bodycolour on blue paper
140 × 192 (5½ × 7⁹⁄₁₆)
Turner Bequest; CCLIX 120
D24685
W985

This view of Paris, taken from the Isle de la Cité, includes some of the city's best-known and most important buildings – the Palais de Justice and Conciergerie on the left, and the Louvre and Tuileries lining the river Seine beyond. Yet it is entirely characteristic of Turner to contrast these imposing monuments with the stuff of ordinary life by including in the foregound a group of lively and colourful figures busily occupying themselves with the flower market. In the far distance can be seen the Pont Neuf which forms the subject of another of Turner's watercolours of Paris for this series (W984).

Turner's views of Paris share an unusually blond and sparkling palette which is in keeping with the impression of vitality they convey. This example, in which pinks and purples predominate, is based on a pencil study in the *Paris and Environs* sketchbook (TB CCLVII f.67 verso; see cat.no.39). It was engraved for *The Rivers of France* by William Radclyffe in 1835 (R 487).

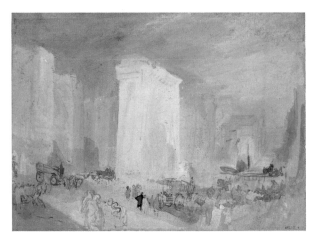

36 **Troyes*** c.1832
Bodycolour on blue paper
142 × 192 (5⁹/₁₆ × 7⁹/₁₆)
Turner Bequest; CCLIX 126
D24691
W 990

37 **Paris: the Porte St Denis*** c.1832
Bodycolour and pen on blue paper
142 × 191 (5⁹/₁₆ × 7⁹/₁₆)
Turner Bequest; CCLIX 6
D24571

Turner's view of Troyes, the ancient capital of
Champagne, was the last illustration to appear in
Wanderings by the Seine. The mellow, glowing palette of
pinks and purples in the original design, although not
dissimilar to that of the 'Marché aux Fleurs' (cat.
no.35), here rather indicates a soft evening light. In
translating the design into a monochrome illustration,
the engraver, J.C. Armytage, chose to emphasise the
long shadows cast by the figures to the left to indicate
that the scene is set in the evening, and also added a
crescent moon (see Lyles and Perkins 1989, cat.no.27).

 There are several pencil studies of Troyes in the
Paris and Environs sketchbook (TB CCLVII ff.101 verso,
103 verso, 108 verso).

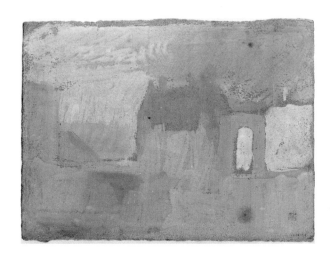

38 **Study of a Group of Buildings, probably in
Paris*** c.1832
Bodycolour with some pen on blue paper
141 × 191 (5⁹/₁₆ × 7¹/₂)
Turner Bequest; CCLIX 38
D24603

The Turner Bequest contains a number of body-
colour drawings of French subjects which, although
never engraved for *The Rivers of France*, are almost cer-
tainly connected with the series. They exist in various
stages of completion. These two unfinished and
extraordinarily bold and vigorous sketches show
Turner blocking in the principal features of the view
in large areas of flat colour as though he were paint-
ing in oil. Both share the blond and creamy palette of

his other Paris views (see cat.nos.34–5), although the exact subject of cat.no.38 has not been established. The view of Porte St Denis has been taken one stage further than cat.no.38, for Turner has begun to add in ink in the foreground groups of figures, carriages and other signs of life appropriate to a busy city area. Perhaps he was at one stage considering using this seventeenth-century triumphal entrance arch to Paris as an alternative subject to that of Ledoux's neo-classical barrière (see cat.no.34 and Alfrey 1982, p.394).

Turner's viewpoint for cat.no.37, with the Porte St Denis presented in acute foreshortening, is remarkably close to an unfinished watercolour which his former colleague, Thomas Girtin (1775–1802), had made in Paris in about 1801 when collecting material for a series of aquatints of the city (Victoria and Albert Museum, repr. T. Girtin and D. Loshak, *The Art of Thomas Girtin*, 1954, ill.no.90). Whether Turner was aware of Girtin's watercolour is not known, but he did own a set of the aquatints themselves, which include a different view of the arch as seen down the Rue St Denis (*Twenty Views in Paris and its Environs*, 1803, private collection).

Paris and Environs sketchbook 1832

39 **Two Views of the Palace of Fontainebleau**
Pencil
Page size 175 × 127 (6⅞ × 5)
Turner Bequest; CCLVII ff.84 verso, 85
D24332, D24333

Towards the end of *Wanderings by the Seine* Leitch Ritchie takes the reader on a diversion from the river to the famous forest and palace at Fontainebleau, but there is no evidence that Turner ever considered making an illustration of the town for *The Rivers of France*. His tour to this area in 1832 was no doubt motivated by his need to collect material for Walter Scott's *Life of Napoleon* (see under cat.no.31). Indeed earlier in the year, John Gibson Lockhart, Scott's son-in-law and future biographer as well as general editor of the proposed new edition of Scott's *Prose Works*, had persuaded Cadell that Turner should prepare for illustration a view of 'Brienne where the Emperor was at school – & of Fontain[e]bleau where he resigned in 1814' (see Finley 1980, p.190).

The detailed pencil study shown here on folio 84 verso is taken from the Cour du Cheval Blanc looking towards the entrance facade of the palace with its famous horseshoe staircase. Turner adapted this sketch for his vignette illustration to the *Life* (W 1115) in which he showed the Emperor standing at the top of the grand staircase aside from his senior staff and contemplating his fate, whilst the chosen envoys waiting below are about to depart for Paris to convey his decision to the capital. It seems likely that Turner was evolving his ideas for the finished composition as he was making this sketch; certainly it is carefully annotated with his observations on the palace's architectural details.

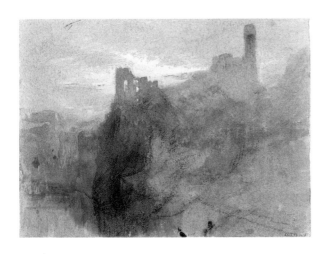

40 Sunset over a Ruined Castle on a Cliff*

*c.*1835–9
Bodycolour on blue paper
140 × 191 (5½ × 7½)
Turner Bequest; CCXXI J
D20243

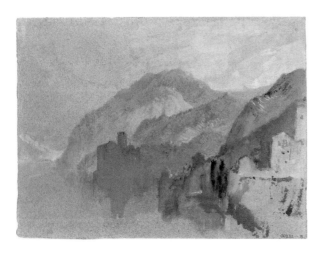

41 Buildings by a Lake* *c.*1835–9
Bodycolour on blue paper
139 × 188 (5½ × 7⁷/₁₆)
Turner Bequest; CCXXI R
D20251

When an advertisement for *Turner's Annual Tour* appeared in 1833, it promised that the forthcoming volume – *Wanderings by the Loire* – would be but the first part in a much larger scheme known as the 'Great Rivers of Europe' or 'River Scenery of Europe'. Nevertheless the two volumes issued between 1834 to 1835 entitled *Wanderings by the Seine* were the last ones to be published by Heath and Longmans in connection with this project with engraved illustrations from designs by Turner (see cat.no.27). It is possible that by the later 1830s the market for such publications was reaching saturation point. Conceivably the original advertisement had never been intended to mean that Turner alone would provide the illustrations for the entire series; for the collaboration between Heath, Longmans and Leitch Ritchie bore fruit in other publications on Continental topography during this period as well (Powell 1991, pp.46 and 61).

Nevertheless the Turner Bequest contains a large number of bodycolour sketches on blue paper similar in style and format to those Turner made for *The Rivers of France* but featuring other rivers in Europe. Many of them are views on the rivers Meuse and Mosel, recently redated to 1839 and fully catalogued (see Powell 1991), but there are many more which still require identification. Cat.no.40 was once thought to show a view of Beilstein on the Mosel, but comparisons with known views of the castle indicate that this identification is incorrect (see Powell 1991, cat.no.62; it may, however, show the same subject as the bodycolour drawing on brown paper in the Turner Bequest known as 'On the Rhine', TB CCCLXIV 305). Cat.no.41, meanwhile, if superficially close to 'The Leyen Burg at Gondorf' (see Powell 1991, cat.no.77; this is the only castle on the Mosel to be situated immediately on the river bank), is unlikely to be a view of that site.

Although, then, not identifiable as views on the Meuse or Mosel, cat.nos.40 and 41 nevertheless share with those bodycolour sketches an extraordinary intensity and beauty of colour. The blue paper helps promote a brilliance in the use of bodycolour which could only have even been achieved in pure watercolour by the application of elaborate wash layers built up by means of a minuscule technique. Cat.no.40 is of particular interest in displaying the complete spectrum of colours (red, orange, yellow, green, blue, indigo and violet), each placed separately and unmixed (Wilton 1982, p.54); the same complete colour range is observable in 'Distant view of Cochem on the Mosel' (Powell 1991, cat.no.68) although in this case they are not placed in their order of appearance in the spectrum.

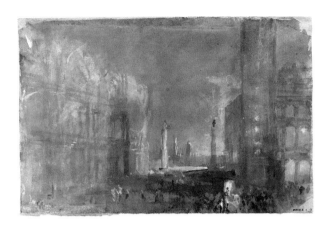

Nurse'. These links with the oil painting, overlooked or even denied by recent scholars, have now been firmly reinforced by Lindsay Stainton (*Turner's Venice*, 1985); indeed the small group of sketches from the brown paper series catalogued here have been deliberately selected to give these links their due emphasis.

42 **Venice: The Piazetta, Night** *c.*1833–5
Watercolour and bodycolour on brown paper
149 × 227 (5⁷⁄₈ × 8¹⁵⁄₁₆)
Turner Bequest; CCCXIX 2
D32250

In addition to the large number of Venetian watercolours in the Turner Bequest on white or grey paper, usually dated to shortly after the artist's third trip to the city in 1840 (see cat.nos.66–70), there is also a group of twenty-nine Venetian subjects in bodycolour on brown paper quite different in character and likely to have been executed on another occasion. The watercolours dating from the 1840s generally take as their theme the city's more open and celebrated vistas (the Lagoon, the Grand Canal, the Bacino) presented, more often than not, under conditions of early morning or early evening light. The group on brown paper, by contrast, show a marked preference for dramatically lit or mysterious interiors (cat.nos.44 and 49), narrow canals, perhaps featuring a single architectural feature (cat.no.48), or highly expressive night scenes (cat.nos.42, 45–48) – subjects in short which allow the artist fully to exploit the combination of rich and vibrant bodycolour with a dark-toned support.

The fascination with Rembrandtian lighting effects which these brown paper studies reveal can be traced in other work by Turner dating from the early 1830s. Furthermore some of the themes of these Venetian sketches share striking parallels with the genesis of the oil painting exhibited by Turner at the Royal Academy in 1836, 'Juliet and her Nurse' (see cat.no.43): for example fireworks (cat.nos.45–6); views over rooftops (cat.no.46); views of the theatre, one thought to show a Shakespearean subject (cat.no.44); and in this example crowds gathering around a puppet or Punch and Judy show just as they do in the lower left-hand section of 'Juliet and her

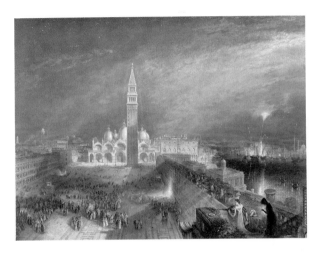

GEORGE HOLLIS (1793–1842) AFTER
J.M.W. TURNER

43 **St Mark's Place, Venice: Juliet and her Nurse** 1842
Line-engraving, first published state (R 654):
423 × 564 (16⁵⁄₈ × 22³⁄₁₆) on wove paper
660 × 772 (26 × 30³⁄₈); plate-mark 539 × 652
(21¹⁄₄ × 25¹¹⁄₁₆)
Engraved inscriptions: '*Painted by J M W Turner RA.*' below image bottom left, '*Engrᵈ by G. Hollis.*' below image bottom right, LONDON: PUBLISHED JUNE 23ᴿᴰ. 1842, BY THOˢ. GRIFFITH, ESQ.ᴿᴱ 14 WATERLOO PLACE, FOR J.M.W. TURNER, R.A.' below image at centre
T05188

This large plate reproduces one of the most important and influential canvases of Turner's later career. Exhibited at the Royal Academy early in 1836, 'Juliet and her Nurse' (B & J 365) became the subject of a vicious attack by the Reverend John Eagles (1783–1885) in an article published in *Blackwood's Magazine* later in the year. It was Eagles's criticisms which fired the seventeen-year-old John Ruskin to compose a letter in Turner's defence, although the artist himself advised Ruskin against publication.

Eagles wrote that the picture was 'a strange jumble', 'a scene … as from models of different parts of

Venice, thrown higgledy-piggledy together, streaked blue and pink, and thrown into a flour tub'. But one of his chief complaints was that Turner should have chosen to place Shakespeare's famous heroine in Venice rather than Verona. It now seems clear that Turner's decision to set his scene from *Romeo and Juliet* in Venice was influenced by the romantic atmosphere of the city; what better place for a story of 'star-cross'd' young lovers than Venice by night? However it may have been in response to criticism over the geographical anachronism of the picture's setting that Turner dropped the Shakepearean association from the subject when it was engraved in 1842 (see Stainton 1985, p.68). The new title, 'St Mark's Place, Venice (Moonlight)' appeared on the second published state of the print, together with four lines from Byron's *Childe Harold's Pilgrimage* and a dedication to Hugh Munro of Novar, who had purchased the picture at the 1836 Academy exhibition.

The episode from *Romeo and Juliet* which is illustrated in Turner's oil painting is from Act II, scene ii. Shortly after her first meeting with Romeo at a masked ball Juliet is musing on her new-found love. Leaning her cheek on one hand, in her other hand she holds the glove that Romeo himself would so like to be: 'See how she leans her cheek upon her hand: / O! that I were a glove upon that hand, / that I might touch that cheek.' Turner seems to have been particularly fond of *Romeo and Juliet*; in 1830 he purchased one of Thomas Stothard's illustrations to the play (Balmanno sale, Sotheby 4–12 May, lot 895; see Grand Palais 1983, cat.no.62).

44 **Venice: The Lovers, ? a Scene from 'Romeo and Juliet'*** *c.*1833–5
Watercolour and bodycolour on brown paper
239 × 314 (9⅜ × 12⁵⁄₁₆)
Turner Bequest; CCCXVIII 20
D32239

This subject has long been identified as a scene from a play. Given that two further bodycolour sketches from this sequence of Venetian subjects on brown paper also show scenes at a theatre (see Stainton 1985, nos.11 and 20), and taking into account that Turner himself is known to have been a keen theatregoer, there seems no reason to question such an identification. Similarly it seems likely that the scene shown is indeed from a play by Shakespeare, since Turner is recorded as having been 'voluble' on the

playwright (Thornbury 1897, p.353), whilst in the 1830s he painted three important canvases on a Shakespearean theme: 'Juliet and her Nurse', 1836 (see cat.no.43); and two scenes from *The Merchant of Venice*, 'Jessica', 1830 (B & J 333), and 'The Grand Canal, Venice' (B & J 368) which was exhibited at the Royal Academy with a quotation from Act II, scene iii in which Shylock determines to have his bond.

If the traditional attribution of this subject as a scene from *The Merchant of Venice* is correct, then Turner has taken considerable liberties with the play. The romantic night scene in which Jessica's lover, Lorenzo, describes to her the beauty of the starlit sky was very popular with artists at the time; it was painted, for example, in oil by Francis Danby (F. Greenacre, *Francis Danby, 1793–1861*, Tate Gallery, 1988, cat.no.28) and in watercolour by Samuel Shelley (British Museum; see also Wilton 1989, p.14). However these artists are faithful to Shakespeare's play in showing the scene in the garden (usually on a terrace) of Portia's house at Belmont. Although it is not inconceivable that Turner has transposed the scene to Venice (just as he moved Juliet to Venice from Verona, see cat.no.43), and even though he had recently painted Jessica leaning out of a casement window (B & J 333), nevertheless the presence of the second woman standing next to her in this study is difficult to explain. An alternative reading of this subject might be that it depicts the episode in *Romeo and Juliet* (shortly after the scene shown in 'Juliet and her Nurse') when Romeo, having spotted Juliet at a window, approaches to speak to her from below (in this study the figure lower left appears to be playing a musical instrument); the presence of the second, apparently older woman standing slightly behind Juliet at the window might then be explained as her nurse, now wearing night dress.

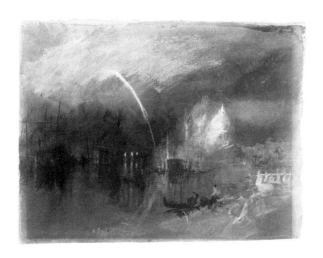

45 **Venice: S. Maria della Salute, Night Scene with Rockets**[*] *c.*1833–5
Watercolour and bodycolour on brown paper
239 × 315 (9³⁄₈ × 12³⁄₈)
Turner Bequest; CCCXVIII 29
D32248

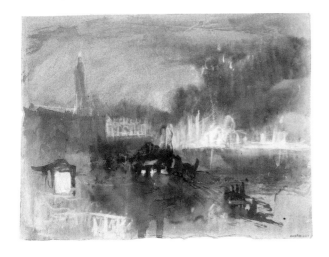

46 **Venice: Fireworks on the Molo** *c.*1833–5
Watercolour and bodycolour with touches of
white chalk on brown paper
226 × 299 (8⁵⁄₁₆ × 11³⁄₄)
Turner Bequest; CCCXVIII 10
D32229

One of the features of Turner's painting 'Juliet and her Nurse' which had so mystified the Reverend John Eagles (see under cat.no.43) was its variety of competing light sources; the picture seemed to him 'neither sunlight, moonlight, nor starlight, nor firelight'. One of those sources of light in the oil was provided by the group of fireworks seen exploding over the island of San Giorgio in the distance.

The rockets being fired in these two sketches function by contrast as the chief sources of light. In cat.no.45, a single rocket shoots up into the inky blackness of the night, providing just enough light to illuminate half the dome of S. Maria della Salute. In cat.no.46, meanwhile, multiple fireworks being let off on the Molo provide ample light to irradiate the entire front of the Ducal Palace, indicated by Turner, just to the left of the composition's centre, in white bodycolour.

In cat.no.45 Turner is looking towards the Salute from the familiar viewpoint on the opposite side of the Grand Canal, from the steps of the Hotel Europa where he was accustomed to stay on his trips to Venice. It has also been suggested that cat.no.46 may have been painted from one of the upper rooms of the same hotel, perhaps at the same time as two other sketches in the brown paper series which similarly show the view across roof-tops looking east towards the Campanile of St Mark's (see Stainton 1985, nos.12 and 13). The latter three, indeed, can be related to the view in 'Juliet and her Nurse' which is taken over the roofs of the Procuratie Nuove looking towards the Campanile – yet another reason to date the Venetian sketches on brown paper to the period *c.*1833–5.

Cat.no.45 is a more complete composition than the majority of Turner's Venetian studies of this date (for two later views of the church, see cat.nos.66–7). Cat.no.46 resembles others in the series in its broader handling; in its colour combination of blues, reds, rich browns and whites it is particularly close to 'Moonlight' (cat.no.47).

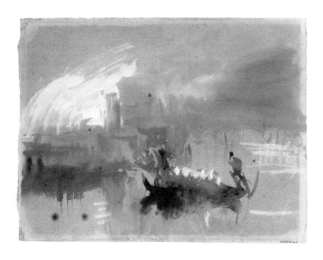

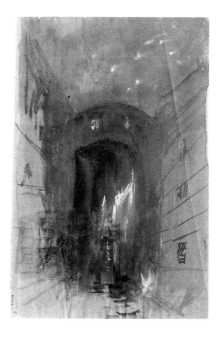

47 **Venice: Moonlight*** *c*.1833–5
Watercolour and bodycolour on greyish-brown paper
215 × 287 ($8^7/_{16}$ × $11^5/_{16}$)
Turner Bequest; CCCXVIII 3
D32222

In this rapid sketch, Turner brilliantly evokes a moonlit scene on the lagoon.

48 **Venice: The Bridge of Sighs, Night***
c.1833–5
Watercolour and bodycolour on brown paper
227 × 153 ($8^{15}/_{16}$ × 6)
Turner Bequest; CCCXIX 5
D32253

The sketches of Venice from the series on brown paper in which Turner adopts an upright format, as in this example, tend to concentrate on a single architectural feature. It has been suggested that this sketch bears more than a passing resemblance to an upright canvas of the Bridge of Sighs exhibited at the Royal Academy in 1835 by William Etty (1787–1849). The Bridge of Sighs had, of course, been so named from the fact that it was used for the passage of prisoners between the Ducal Palace (seen here in Turner's watercolour to the left), where they were examined by Inquisitors of State, and the state prisons themselves on the other side. Etty's oil took as its theme (as was explained in an extract in the Royal Academy catalogue) one of the former practices at the prisons whereby the bodies of executed criminals would be taken away to be disposed of in the lagoon (see Stainton 1985, no.27, who also reproduces Etty's oil as fig.5); and it has been argued that the same episode can just be made out in Turner's sketch (presumably the agitated brushwork lower right near the water, including the touches of red, perhaps indicating blood). If Turner's design was indeed influenced by Etty's oil, this would be another reason to date the whole group of Venetian studies on brown paper to *c*.1835, a date which would also be consistent with the evolution of 'Juliet and her Nurse'.

This is one of the most lyrical of all Turner's Venetian bodycolour sketches of this date. The barred windows of the prison to the right are brilliantly suggested by a few calligraphic strokes, almost resembling the characters of oriental script.

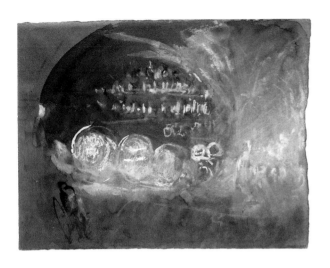

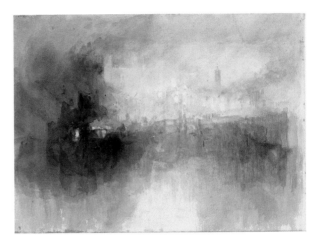

49 Venice: ? The Interior of a Wineshop
c.1833–5
Watercolour and bodycolour on brown paper
234 × 308 (9¼ × 12⅛)
Turner Bequest; CCCXVIII 21
D32240

Many of the Venetian bodycolour sketches on brown paper were executed with such rapidity and freedom of handling that their subjects can be difficult to interpret. This sketch has been identified as the interior of a wineshop, the three rounded forms in white bodycolour in the foreground presumably corresponding with barrel ends.

50 Colour Study: The Burning of the Houses of Parliament* 1834
Watercolour
233 × 325 (9³⁄₁₆ × 12¾)
Turner Bequest; CCLXXXIII 2
D27847

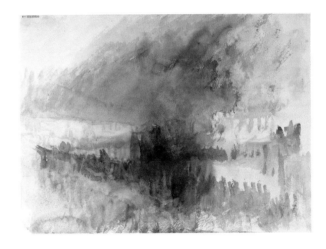

51 Colour Study: The Burning of the Houses of Parliament* 1834
Watercolour
232 × 326 (9⅛ × 121¹³⁄₁₆)
Turner Bequest; CCLXXXIII 6
D27851

These two studies belong to a sequence of nine watercolours, all originally from the same sketchbook, which show a conflagration across water (the others are TB CCLXXXIII 1, 3–5 and 7–9). They have always been identified as showing the burning of the old Houses of Parliament which took place on 16 October, 1834, and which Turner recorded in two famous oil paintings exhibited at the British

Institution and Royal Academy the following year (B & J 359 and 364), in an unfinished watercolour (cat.no.52) and in a vignette illustration engraved for *The Keepsake* in 1835 (W 1306).

Turner is known to have watched the fire, and indeed he spent part of the night on a boat on the river. The nine colour sketches, however, present certain problems, for in none of them can the unmistakeable shapes of St Stephen's Chapel or Westminster Abbey be made out as they can in the two oils (although the tower visible in cat.no.50 could conceivably be intended as one of the pinnacles of Westminster Hall). However the watercolours do correspond in general atmosphere to the oil paintings of the fire, and can probably be explained as meditations strongly generalised after the event rather than records of what Turner actually saw. It would, in any case, have been extremely difficult for the artist to have made coloured sketches on the spot in view both of the darkness and the general chaos which the event engendered; for vast crowds rushed out to watch the dramatic spectacle, and the army was called in to assist the police in controlling the throng (even Turner's pencil notes of the fire recorded in a small sketchbook, TB CCLXXXIV, have been regarded as too slight to be certainly connected with the fire).

Turner's two oils of the burning of the Houses of Parliament, both now in America, are taken from different viewpoints and record two different moments in the fire. The picture in Philadelphia (B & J 359; fig.4 on p.17) is taken from the Surrey side (south bank) of the Thames from a point slightly to the left of Westminster Bridge and almost exactly opposite the Palace of Westminster; vast crowds are shown in the foreground watching the spectacle. The Cleveland picture, meanwhile (B & J 364), is taken from further downstream near Waterloo Bridge (still on the Surrey side of the Thames) later in the evening when the initial violence of the blaze had abated somewhat. It has been suggested that the nine watercolours of the fire similarly chart its progress at different times of the night as Turner walked from Westminster to Waterloo Bridge over the course of several hours (see Dorment 1986).

According to this theory, cat.no.50 would represent one of the earliest views of the fire, perhaps taken from a viewpoint just to the left of Westminster Bridge looking directly across to the Palace of Westminster; and cat.no.51, although still related to these earlier views, would have been taken a little later when Turner had moved farther back from the bridge, since it appears to show the south-bank parapet stretching off to the left, crowded with spectators (in which case the Philadelphia oil would appear to

be an amalgamation of both sketches). Even if Turner does indeed appear to be observing the same conflagration in these colour sketches from different angles, it has to be admitted that this theory, however, fascinating, remains inconclusive.

The theme of fire and water is one which held particular fascination for Turner in the mid-1830s; he made an oil of a 'Fire at Sea' about this time (Tate Gallery; B & J 460) and a watercolour showing a 'Fire at Fenning's Wharf, on the Thames at Bermondsey', 1836 (W 523).

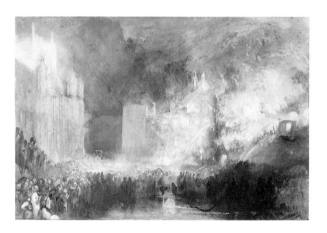

52 **The Burning of the Houses of Parliament**[*]
1834
Watercolour and bodycolour, with scraping out and stopping out
302 × 444 (11⁷⁄₈ × 17¹⁄₂)
Turner Bequest; CCCLXIV 373
D36235
W 522

As well as watching the burning of the Houses of Parliament from the southern side of the Thames (see cat.nos.50–1), the existence of this watercolour by Turner showing the fire-fighters in Old Palace Yard itself indicates that the artist must have crossed Westminster Bridge during the course of the evening of 16 October to observe the fire at closer quarters. Here Turner conveys the drama of the spectacle through the medium of a large crowd, whose excitement and fascination we share.

About 1835 Turner made a vignette of the fire, showing the spectacle from water level through one

of the arches of Westminster Bridge, which was engraved for *The Keepsake* (see under cat.nos.50–1). The disaster, indeed, prompted a surge of engravings and it seems likely that this watercolour, although not finished, may have also been intended for publication in engraved form. The occasion had been very much a 'popular' one, and had aroused strong feelings, for the fire was associated in people's minds with the recent and bitterly disputed passage of the Reform Bill. Some people regarded the fire as a retribution for recent events; others saw it as a confirmation of the righteousness of their convictions, a standpoint which could be justified by the fact that both Westminster Hall and Westminster Abbey had survived – buildings 'endeared to numerous generations of Englishmen as monuments of the antiquity and glory of their country' (*The Times*, 18 October, 1834).

If indeed intended for publication in the form of an engraving, it is also possible that Turner's watercolour may contain a more polemical message. The Cleveland version of the burning of the Houses of Parliament (B & J 364) depicts the moment early the following morning when a floating fire-engine (clearly labelled 'Sun Fire Office' in the picture) had managed to get up the Thames on the rising tide – it arrived too late to prevent the worst of the destruction, although it had a 'prodigious' effect on the burning embers. In 1834 the fire services in Britain were still in the hands of the various insurance companies. It has been suggested that Turner's watercolour might have begun as a possible illustration to the pamphlet, *Plan for the Establishment of a Metropolitan Fire Police* (published January 1835), written by Captain G.W. Manby (1765–1854) whose newly invented life-saving apparatus the artist had already made the subject of a picture earlier in the decade (B & J 336); for in this document the recent fire was judged to have been so destructive 'for want of one presiding head – for want of well-arranged and preconcerted arrangements – for want, in one word, of an organised NATIONAL FIRE POLICE' (Gage 1987, p.233).

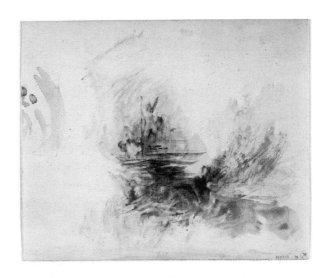

53 **Satan Summoning his Legions*** *c.*1834
Watercolour
186 × 230 (7^{5}/$_{16}$ × 9^{1}/$_{16}$)
Turner Bequest; CCLXXX 78
D27595

The Turner Bequest contains many broad colour studies like this one which represent preliminary ideas for the large quantity of vignettes the artist was commissioned to make in the 1830s as illustrations to poets such as Rogers (see cat.nos.9–13), Campbell and Milton. Some of them incorporate ideas that were never pursued as far as a finished design, and this is just such an example. Representing the famous episode in Book One of Milton's epic poem *Paradise Lost*, when Satan summons his legions on the burning lake, Turner's design is clearly an idea for an illustration to Macrone's edition of Milton's *Poetical Works*, 1835 – a volume to which he contributed seven illustrations at this date, including three other episodes from *Paradise Lost* itself (W 1264–6). The combination of brilliant vermilion and yellow is characteristic of a number of these unfinished vignette designs.

Milton's influence had been undisputed throughout the eighteenth century, and this episode from *Paradise Lost* was one of the great set-pieces of late eighteenth-century British art: it was the subject of Thomas Lawrence's diploma picture at the Royal Academy in 1797 (repr. K. Garlick, *Thomas Lawrence*, 1954, pl.35), for example, as well as of a fine etching by James Barry (repr. W.L. Pressley, *James Barry: The Artist as Hero*, exh. cat., Tate Gallery 1983, cat.no.50). Turner follows the example of most of his predecessors in depicting Satan with both arms upraised, and adopts an equally heroic pose.

an important ingredient in Turner's illustration of the religious and Miltonic sublime. In combination with the oval shape of the design, the use of such figures recalls Baroque ceiling decoration and anticipates one of the artist's great 'circular' paintings of the 1840s, 'Light and Colour (Goethe's Theory) – the Morning after the Deluge' (Tate Gallery, B & J 405; and see Wilton 1980, p.140).

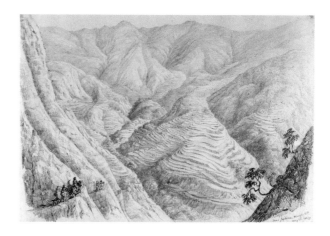

EDWARD GOODALL (1795–1870) AFTER
J.M.W. TURNER

54 The Fall of the Rebel Angels 1835
for Milton's *Poetical Works*
Line-engraving, vignette, first published state
(R 599): approx. 115 × 85 (4⅛ × 3⁵⁄₁₆) on india
paper laid on wove paper 220 × 155 (8¹¹⁄₁₆ × 6⅛);
plate-mark 216 × 150 (8½ × 5¹⁵⁄₁₆)
Engraved inscriptions: '*JMW Turner, RA.*'
below image bottom left, '*E. Goodall. / Printed
by J. Yates.*' below image bottom right, '*London,
John Macrone, 3, St. James's Square,* MDCLXXXV.'
below image at centre
T06286

LT.-COL. GEORGE FRANCIS WHITE
(1808–1898)

55 View near Jubberah in the Himalayas 1829
Pencil
251 × 364 (9⅞ × 14⁵⁄₁₆)
Inscribed: 'Near Jubbera, Himal. M^ts / May 23^d
1829'
T06477

Like 'Satan Summoning his Legions' (cat.no.53), this subject from Milton's *Paradise Lost* illustrating the fall of the rebel angels is one which often recurs in late eighteenth-century British art; one of the most dramatic renderings of the scene is the large watercolour by Edward Dayes recently acquired by the Tate Gallery (T05210; fig.3 on p.14). Turner's original design for this version of the subject, made for Milton's *Poetical Works*, is now untraced, but Rawlinson records an episode which relates to its translation by Edward Goodall. The engraver's son, Frederick Goodall, reported that 'when his father was engraving this plate, Turner wrote across the upper part of the proof "put me in innumerable figures here." These the engraver himself had to draw' (Rawlinson 1913, p.313; see also cat.no.13).

The impression of cataclysm created by the vast swarms of figures which tumble out of the heavens is

This is one of three drawings recently acquired by the Tate Gallery which were made by the amateur artist Lt.-Col. George Francis White of the thirteenth regiment of Foot when stationed in India between 1825 and 1846. Like the two other drawings in the Gallery's possession ('Valley of the Dhoon from Landour', T06478, and 'Rocky Islets on the Ganges at Colgong', T06479), this view near Jubberah served as the starting point for a finished watercolour by Turner (cat.no.56) which was then translated into an engraved illustration for White's *Views in India, Chiefly among the Himalaya Mountains* (1836–7). Altogether, Turner contributed seven illustrations to White's publication (W 1291–97), the remaining twenty-three being supplied by other professional artists such as Clarkson Stanfield (1793–1867), David Roberts (1796–1864) and Charles Bentley (1806–1854), amongst others.

White was an enthusiastic and accomplished amateur artist who made a large number of drawings throughout his career, both in pencil alone like this example and in pencil with brown washes heightened with white bodycolour. His pencil drawings are generally very detailed and, like this one, show a good understanding of spatial recession. Some of his Indian drawings were also used by Robert Burford in a panorama of the Himalayas exhibited at Leicester Square in 1847. Further details about his life and work can be found in the catalogue of an exhibition held at the Victoria and Albert Museum in 1982 entitled *India Observed* (see Bibliography).

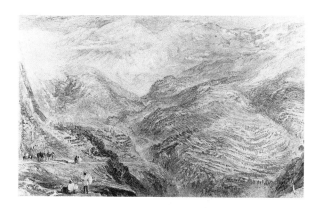

56 **View near Jubberah** *c.*1835
 Watercolour
 127 × 203 (5 × 8)
 Blackburn Museum and Art Gallery
 W 1294

Thanks to his prodigious memory for natural phenomena and the extraordinary power of his imagination, Turner could transform a humble amateur sketch into a powerful and elaborate composition. He had first transcribed amateur drawings in 1818 when working on James Hakewill's *Picturesque Tour of Italy*; relying on sketches by other artists of places he had himself not visited was to become an important feature of his work for the engraver. As well as making finished watercolours from drawings by Lt.-Col. George Francis White for the latter's *Views in India* (see under cat.no.55), as in this example, during the 1820s and 1830s Turner also worked up amateur sketches as illustrations to the works of Lord Byron (see under W 1210–35) and to Finden's *Landscape Illustrations of the Bible* (W 1236–63).

When making finished watercolours from sketches by others, Turner would invariably seek to exaggerate and dramatise a landscape's features even if – as in this case – he was compressing his information into

a much smaller area. A comparison between this watercolour and White's preliminary drawing (cat. no.55), for example, reveals how Turner has increased the sense of far-flung distance in his design by introducing a measured atmospheric recession; the snow-covered peaks in the distance are half lost in cloud. However, Turner has greatly tamed the left-hand foreground of White's view, so that the figures once travelling on a precipitous path are now safely positioned on the edge of a platform of rock.

White's *Views in India* was very popular and was reissued a number of times with slight changes of text. The description accompanying this illustration in the 1836–7 edition reads: 'The village of Jubberah lies north of the Mussooree and Marma ridges, on the route from the latter towards the source of the Jumna. The village is perceptible in shadow, on a height near the centre of the distance. In this view, the curious stripy effect produced by the mode of cultivating the sides of the hills ... which, next to their great steepness and ruggedness, generally attracts the traveller's eye, is here ... distinctly portrayed' (quoted Archer and Lightbown 1982, p.147). As this description indicates, Turner's design includes in the very far distance the village of Jubberah itself, which can also be made out in White's drawing.

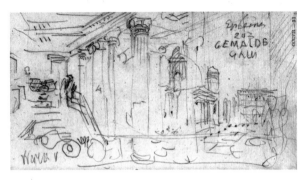

Dresden and Berlin sketchbook 1835

57 **Two Views of the Altes Museum, Berlin: a distant view of the museum, with the Domkirche on the right; and a view looking out from the museum's portico, with another view of the Domkirche**
Pencil
Page size 161 × 87 (6½ × 3½)
Inscribed (f.31): '[?Eingang zum] GEMALDE Galle[rie]'
Turner Bequest; CCCVII ff.30 verso, 31
D31079, 31080

This sketchbook was used by Turner on an extended tour to central Europe undertaken at some stage during the early to mid-1830s. The exact date of the tour has long been a subject of controversy, although in recent years it seemed to have been firmly established that it formed part of the itinerary which took Turner on his second visit to Venice in 1833 (George 1984, pp.2–21).

However the sketch on folio 31 showing the view from the portico of the Altes Museum looking towards the Lustgarten (partly obscured by Turner's inclusion of the Domkirche, which is not in fact visible at this point) is proof that the tour in question could not have taken place before 1834 at the earliest. For although Turner's sketch is rapidly drawn, there can be no mistaking his inclusion at the top of the flight of steps to the left the cast iron copy of the

Warwick Vase which had been presented to King Friedrich Wilhelm III by the Tsar of Russia and which was installed on the staircase's upper landing by the middle of January 1834 (a report in the *Berlinische Nachrichten* for 1 March 1834 states that the vase had now been *in situ* for a period of six weeks, see W. Arenhövel, *Eisen statt Gold*, exh cat, Berlin 1982, no.396).

The original white marble vase (today in the Burrell Collection, Glasgow) had been discovered in the ruins of Hadrian's villa near Tivoli in 1771, and soon after came into the possession of the Earl of Warwick; at first Warwick forbade casts to be made of it, but eventually replicas in bronze and cast iron were produced, as well as copies on a reduced scale in silver, bronze, marble, porcelain and terracotta (see Snodin 1991, cat.nos.134–5 and F. Haskell and N. Penny, *Taste and the Antique* 1981, p.67). Turner has firmly pencilled in on his sketch the elaborately twisted handles which are one of the vase's most prominent features, and which can similarly be seen in Carl Daniel Freydanck's representation of the vase in his painting of the museum's portico at a slightly later date (fig.6 on p.21 and Snodin 1991, cat.no.55).

Officially opened in 1830, the Altes Museum was one of the many buildings commissioned in the 1820s and 1830s from the architect Karl Friedrich Schinkel (see under cat.no.7) as part of a large-scale building programme in Berlin undertaken by Friedrich Wilhelm III; this sketchbook also includes, for example, studies of Schinkel's Schauspielhaus, the Neue Wache and the City Palace at Pariser Platz (see George 1984, p.2). The rapid growth of the royal collections, for which the museum was originally built, necessitated the erection of another museum between 1841 and 1855, and from then on Schinkel's museum was known as the Altes Museum. On folio 30 verso of this sketchbook Turner shows the Lustgarten facade of the museum, with the Domkirche by Johann Boumann the elder on the right; the artist has inscribed the number '18' above the museum to indicate the exact number of columns which make up the portico and has also marked in, at the centre of the facade, the position of the double staircase inside the portico.

There are also studies of Dresden in this sketchbook, in particular of the paintings in the Dresden Gallery, as well as a list of simple English phrases with their German translations.

Dresden sketchbook 1835

58 **Two Views of Prague from the Charles Bridge**
Pencil
Page size 159 × 98 (6¼ × 4)
Turner Bequest; CCCI ff.29 verso, 30
D30353, 30354

For reasons explained in the introductory essay to this catalogue, the most likely date of Turner's tour to central Europe is 1835. He probably travelled from Copenhagen across the Baltic before working his way down to Berlin and then to Dresden (see cat.no.57 and also the *Dresden and River Elbe* sketchbook, TB CCCVI). His journey from Dresden to Prague can be traced in this sketchbook. Another sketchbook associated with this tour, the *Rhine, Frankfurt, Nurenberg and Prague* sketchbook (TB CCCVI) may indicate that the artist returned to England via Germany; certainly it now seems unlikely that he continued on from Prague to Vienna (and thence to Italy) as was previously supposed.

One of the favourite points from which to view the city of Prague in Turner's day (as today) was from the Charles Bridge spanning the river Moldau (George 1984, p.6), and it was from that spot that the artist made these two sketches. The famous Baroque statuary lining the Charles bridge forms a prominent feature in the foreground of both sketches, although the views beyond are in opposite directions: folio 29 verso shows the castle precinct in the distance, with the tower of St Vitus' Cathedral and the twin towers of the Basilica of St George to the far right; whilst folio 30 shows the view looking back towards the older part of the city. There are other studies of Prague in this sketchbook, such as two views of the Tyn church (see George 1984, ill.5), and – as its title suggests – of Dresden as well.

Turner would almost certainly have referred to the studies of Prague made in this sketchbook when composing the watercolour vignette of 'Prague – Kosciusko' (w 1273) which was engraved for Thomas Campbell's *Poetical Works* in 1837.

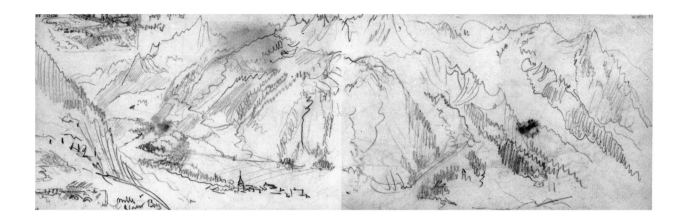

Val d'Aosta sketchbook 1836

59 **Mont Blanc from Brévent, with the Glacier des Bossons and the Ascent of the Montanvert**
Pencil
113 × 190 (4⁷⁄₁₆ × 7½)
Turner Bequest; CCXCIII ff.26, 25 verso
D29082, 29081

In 1836 Turner embarked on a tour to Switzerland in company with his friend and patron, Hugh Munro of Novar. It appears to have been Turner's own suggestion that the two men should travel together and Munro, himself an amateur artist, seems to have benefited from Turner's advice on at least one occasion during the tour (Finberg 1961, pp.360–1). For much of the trip, the two men retraced the route taken by Turner on his first visit to Switzerland in 1802. After travelling through France to Geneva, and making a circuit of the lake embracing Lausanne, Vevey and Chillon, they travelled south through Bonneville and Cluse to Chamonix and then through the Val d'Aosta to Turin where they parted company. Their itinerary can be followed in two small sketchbooks used by Turner on the tour, this one and the *Fort Bard* sketchbook (TB CXCIV).

For the most part the two sketchbooks are filled with small and rapid pencil studies – often several to a page, this being typical of Turner's method of gathering information by this date. However the sketchbooks also include a number of double-page spreads, like this one, featuring a wider panorama from an elevated position. Indeed Thornbury, the artist's first biographer, relying on information given to him by Munro, recorded how on this tour 'Turner . . . at some distance fom his companion – generally much higher – applied himself to work in a silent, concentrated frame of mind. The superior elevation he required for the purpose of obtaining greater distance

and more of a bird's-eye view' (Thornbury 1897, p.104).

The view shown here was identified by Finberg (1909, p.945), with the help of John Ruskin, as looking towards Mont Blanc from Brévent (f.25 verso), with the the Glacier des Bossons and the Ascent of Montanvert (f.26). On folio 20 verso of the same sketchbook there are three tiny mountainous studies of which the central one also appears to be a view of Mont Blanc (repr. Alfrey 1982, p.475). And it was probably during this tour that Turner made colour studies of Mont Blanc (see under cat.no.60), and of the Glacier des Bossons (British Museum, W 1440; repr. Wilton 1980, pl.23).

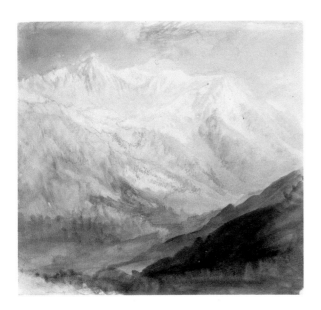

60 Mont Blanc, ? from Brévent* *c.*1836
Pencil and watercolour
256 x 280 (10^1/$_{16}$ × 11)
Turner Bequest; CCCLXIV 152
D35996

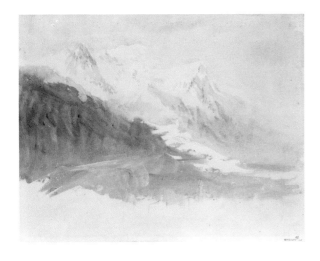

61 Colour Study; Mont Blanc, ? from Brévent*
*c.*1836
Watercolour
245 × 306 (9^5/$_8$ × 12^1/$_{16}$)
Turner Bequest; CCCLXIV 93
D35936

Although Turner produced no finished watercolours as a result of his 1836 tour to Switzerland, a large group of colour studies of mountainous scenery have long been associated with the trip – some in public or private collections (W1430–56), and others, like this one, in the Turner Bequest. Evidence that Turner did indeed make colour sketches on this tour, perhaps 'en plein air', exists in the form of Munro of Novar's statement that 'I don't remember colouring coming out till we got into Switzerland' (Finberg 1961, p.360).

It seems likely, indeed, that Turner would have filled several of his roll sketchbooks with colour studies like this one and that, now dismantled, their contents have become mixed up with other sketches dating from subsequent trips he made to Switzerland in the early 1840s. Indeed cat.nos.60, 62–3, a further twenty-four studies in the Turner Bequest and three others outside it (W1435, 1441 and 1515) have been proposed as the contents of one of these roll sketchbooks, named 'Dora Baltea' after the river which flows through the Aosta valley (Serota 1970, pp.124–5; see also Wilton and Russell 1976, p.33). Certainly cat.nos.60 and 62–3 all share the same dimensions, as well as the square format which has been associated with this tour in particular.

Another feature which tends to characterise the colour studies linked to Turner's visit to Switzerland in 1836 is their strong colour and a rather dark tonality, although it is not unusual, as in cat.no.60 for example, to see softer colours used in combination with black. If cat.no.60 is indeed a study made on the tour itself, it is difficult to establish what relation it bears to cat.no.61, a less advanced colour study which also shows Mont Blanc (the viewpoint in cat.nos.60 and 61 is probably from Brévent, although it could alternatively be from the valley of Chamonix). In its size and proportions, cat.no.61 does not correspond with the other sheets of the proposed 'Dora Baltea' sketchbook, and it is suggested here that it could be a colour beginning postdating cat.no.60. The light falling on the snow-covered peaks (suggested where Turner has left the paper white) is beautifully observed.

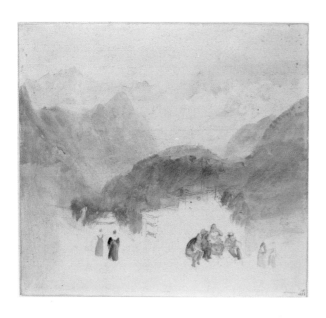

62 **Mountains, with Houses and Figures in
the Foreground: ? View near the Pass of
Faido**[*] *c.*1836
Pencil and watercolour
256 × 280 (10¹/₁₆ × 11)
Turner Bequest; CCCLXIV 128
D35971

Another feature common to many of the colour stud-
ies associated with Turner's 1836 tour to Switzerland,
including cat.no.62, is the artist's use of a rather rich
and solid colouring, with highlights scraped out with
the blunt end of a brush. Nevertheless cat.no.62 pre-
sents something of a problem. On the one hand it is
datable to *c.*1836 both in the use of this technique and
in its resemblance to another watercolour dating
from this tour, 'The Castle of Chillon' (W1456), in
which Turner has similarly worked up the middle dis-
tance but left the foreground rather vague. On the
other hand, both cat.nos.62 and 63 have been
identified as views near the Pass of Faido (see Wilton
and Russell 1976, p.77) which Turner did not visit on
his tour to Switzerland in 1836. Furthermore, the
rather strange effect in cat.no.62 of figures looming
out of the foreground in bright national costume is
directly comparable with that produced in another,
more finished watercolour by Turner of Faido in the
Fitzwilliam Museum, Cambridge (W1493), and dated
1843 on the evidence that the artist certainly did visit
Faido that year. Either the identification of cat.nos.62
and 63 is incorrect, or the two studies do in fact
belong to a later tour – perhaps the one made in
1843, or even one undertaken in the later 1830s that
has not yet been documented.

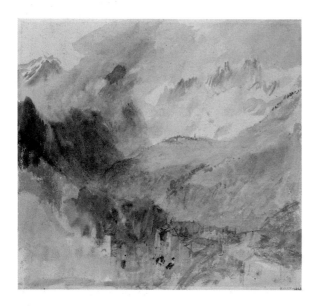

63 **Mountains: ? View near the Pass of Faido**[*]
*c.*1836
Watercolour
255 × 279 (10¹/₁₆ × 11)
Watermarked: B,E&S / 1827
Turner Bequest; CCCLXIV 121
D35964

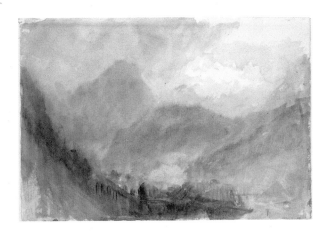

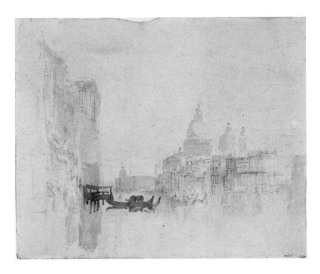

64 Grey Mountains *c.*1836–40
Grey wash with touches of yellowish-brown wash
190 × 280 (7¹/₂ × 11)
Turner Bequest; CCLXIII 262
D25385

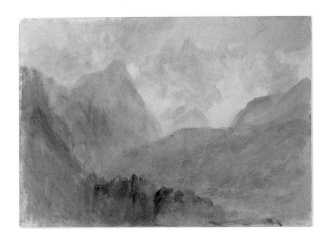

65 Among the Mountains *c.*1836–40
Watercolour
194 × 277 (7⁵/₈ × 10⁷/₈)
Turner Bequest; CCLXIII 258
D25381

These two related studies do not seem to be connected with any finished watercolour by Turner, and like many of the sketches of mountainous scenery in the Turner Bequest are rather difficult to date. The thickish pigment to the lower left of cat.no.64, and the striated effect produced in the area of wash to the right where colour has been lifted with the blunt end of a brush (see under cat.nos.62–3), could link them with Turner's 1836 tour to Switzerland – although they may in fact derive from almost any of his tours through Europe in the 1830s.

66 Venice: S. Maria della Salute with the Traghetto S. Maria Zobenigo *c.*1840
Watercolour over pencil
243 × 304 (9⁹/₁₆ × 12)
Turner Bequest; CCCXVI 1
D32138

Unlike Turner's trip to Venice in 1833, the one he made to the city in 1840 is well documented; we know, for example, that on this occasion he remained for two weeks – longer than on either of his previous visits. A study of S. Maria della Salute in the *Rotterdam to Venice* sketchbook (TB CCCXX, f.78 verso) corresponds fairly closely to this watercolour, but generally the pencil sketches made on this tour functioned more as a form of mental exercise than as a process of collecting reference material for later use (see Stainton 1985, p.22); further pencil studies made on this trip can be found in the *Venice and Botzen* (TB CCCXIII) and *Coburg, Bamberg and Venice* (TB CCCX) sketchbooks.

The colour sketches associated with Turner's trip to Venice in 1833 had tended to concentrate on enclosed vistas or interiors. However those made during, or shortly after, the trip in 1840 show his interest reverting to the themes that had occupied his attention on his very first trip to the city in 1819 – the reflections of light on water, and the fascinating and ever-changing relationships of buildings, water and sky. These studies vary in handling from the most summary and economical sketch, such as this example, to more detailed and complete watercolours such as cat.nos.69–70, although even these are not strictly 'finished'.

It has been suggested that this watercolour may have been used by Turner when working up a more elaborate version of the subject which once belonged

to Ruskin and is now in the Ashmolean Museum in Oxford (Stainton 1985, no.93 and repr.; w 1363); the artist's viewpoint is mid-stream on the Grand Canal, close to where the Accademia Bridge was to be erected in 1854.

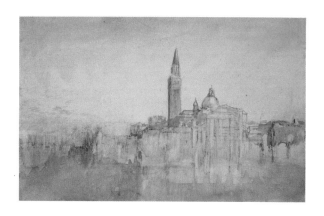

68 Venice: S. Giorgio Maggiore from the Dogana *c.*1840
Watercolour and bodycolour over pencil
193 × 281 (7⁹⁄₁₆ × 11¹⁄₁₆)
Turner Bequest; cccxvi 28
d32165

Turner made a sequence of studies of Palladio's church of S. Giorgio Maggiore on his 1840 visit to Venice, two of which – including this example – show the church at sunset (see also Stainton 1985, pls.77 and 84). Situated in a magnificent position on a separate islet facing St Mark's, the church's white facade, tall campanile and brick building all reflect the changing light of the lagoon, a feature known to be especially beautiful in the evening.

The *Autobiography* of the watercolourist William Callow (1812–1908) contains an interesting glimpse of Turner at work during this visit, sketching the church of S. Giorgio: 'The next time I met Turner was at Venice, at Hotel Europa, where we sat opposite at meals and entered into conversation. One evening whilst I was enjoying a cigar in a gondola I saw in another one Turner sketching San Giorgio, brilliantly lit up by the setting sun. I felt quite ashamed of myself idling away the time whilst he was hard at work so late' (quoted Stainton 1985, p.22).

It is likely that a number of the studies made by Turner on this trip, including perhaps some of San Giorgio, were coloured in front of the motif. With its exquisite colour harmonies ranging from yellows and pinks to complementary blues and orange-red, and positively glowing with reflected light, this watercolour is one of the most radiant of all Turner's watercolours of Venice.

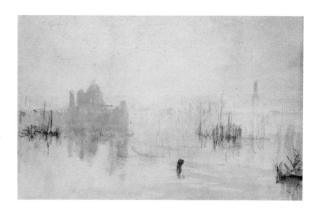

67 Venice: S. Maria della Salute and the Dogana *c.*1840
Watercolour
221 × 320 (8¹¹⁄₁₆ × 12⁵⁄₈)
Turner Bequest; cccxv 14
d32130

Some of the most magical and dreamlike of Turner's views of Venice associated with the 1840 visit are those which, like this one, originally formed part of a roll sketchbook (tb cccxv); another such sheet is cat.no.70. In this study of the Salute at sunset, the impression of still and suffused watery light is brilliantly rendered in a sequence of delicate and translucent washes of yellow, turquoise and grey; the only suggestion of solid form is an intermittent boat mast or post in the water, indicated by Turner with a few summary brushstrokes of dry brown pigment. There is a similar view to this one, but with more intense colouring, showing the Salute from closer to (tb cccxv 17, repr. Stainton 1985, pl.53).

The roll sketchbook in question is watermarked 1834, and thus can almost certainly be associated with Turner's last visit to Venice in 1840 (Royal Academy 1974–5, pp.154–5, Wilton 1979, p.462 and Stainton 1985, p.27). Indeed it provides the principal stylistic evidence around which these later Venetian views can be grouped; for despite obvious differences in treatment between the individual drawings, there are clear interrelationships in terms of palette, themes and handling.

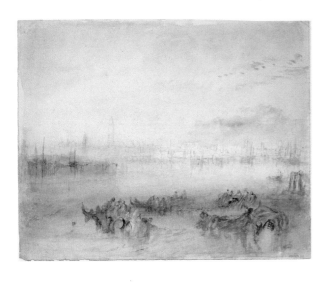

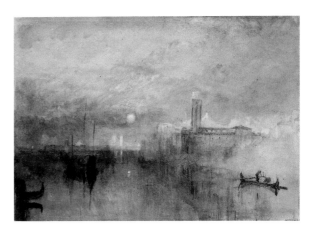

69 Venice: The Riva degli Schiavoni from the Channel to the Lido[*] *c.*1840

Watercolour and bodycolour with pen and brown and red ink

245 × 305 (9⅝ × 12)

Turner Bequest; CCCXVI 18

D32155

The juxtaposition of bands of cool turquoise and warm yellow (sometimes, as here, in combination with pink) is one often found in Turner's later work, and particularly in the Venetian watercolours dating from his visit to the city in 1840 (see also cat.no.67). Sometimes, as in this example, Turner would then superimpose a network of fine lines to define details, such as the rapid strokes of brown wash indicating the forms of the buildings along the Riva in the distance, or – more strikingly – the red pen lines which give substance and movement to the fishermen hauling in their nets in the foreground. As well as showing fishermen at work with their nets, Turner also painted them putting out to sea in their colourful boats – the most celebrated example of this subject being his oil of 'The Sun of Venice Going to Sea' in the Tate Gallery (B & J 402).

70 Venice: Moonrise, the Giudecca and the Zitelle in the Distance[*] *c.*1840

Watercolour

221 × 319 (8¹¹⁄₁₆ × 12⁹⁄₁₆)

Turner Bequest; CCCXV 10

D32126

One of the most poetic of all Turner's Venetian watercolours, this drawing once formed part of a roll sketchbook which is now dismembered (see under cat.no.67). There is some uncertainty as to Turner's viewpoint in the watercolour. If, as is thought, the campanile in the foreground is that of the church of San Zaccaria, then the view is looking to the west (with the Giudecca Canal in the distance) and thus must show the moon setting in the early morning, rather than moonrise (Stainton 1985, no.48).

BIBLIOGRAPHY

All books published in London unless otherwise stated.

Alfrey, N. (*et al.*), *Turner en France*, exh. cat., Centre Culturel du Marais, Paris 1982

Archer, M. and Lightbown, R., *India Observed: India as Viewed by British Artists 1760–1860*, exh. cat., Victoria and Albert Museum, 1982

Bain, I., *William Daniell R.A: A Voyage Round Great Britain 1814–1825*, exh. leaflet, The British Council 1979

Butlin, M., and Joll, E., *The Paintings of J.M.W. Turner*, revised ed., New Haven and London, 1984

Cleveland Museum of Art, *Dreadful Fire!*, exh. cat., Cleveland, Ohio 1984

Cormack, M., *J.M.W. Turner, R.A., 1775–1851: A Catalogue of Drawings and Watercolours in the Fitzwilliam Museum, Cambridge*, 1975

Daniell, W., *A Voyage Round Great Britain, Undertaken between the Years 1813 and 1823. . .*, reprint in reduced size published by the Tate Gallery in two volumes, 1978

Dorment, R., *British Painting in the Philadelphia Museum of Art*, Philadelphia, 1986

Finberg, A.J., *A Complete Inventory of the Drawings of the Turner Bequest*, 2 vols., 1909

Finberg, A.J., *The Life of J.M.W. Turner, R.A.*, second ed., Oxford 1961

Finley, G. 'Turner and Scott: Iconography of a Tour', *Journal of the Warburg and Courtauld Institutes*, 1972, vol.35, pp.359–85

Finley, G., *Landscapes of Memory: Turner as Illustrator to Scott*, 1981

Gage, J. (ed.), *The Collected Correspondence of J.M.W. Turner*, 1980

Gage, J., *J.M.W. Turner: 'A Wonderful Range of Mind'*, 1987

George, H., 'Turner in Europe in 1833', *Turner Studies*, 1984, vol.4, no.1, pp.2–21

Grand Palais, *J.M.W. Turner*, exh. cat., Paris 1983

Hauptman, W., *Magnificent Switzerland: Views by Foreign Artists 1770–1914*, exh. cat., Lugano and Geneva, Milan 1991

Herrmann, L., *Turner Prints*, 1990

Holcomb, A., 'The Vignette and the Vortical Composition in Turner's Oeuvre', *Art Quarterly*, 1970, vol.32, no.1, pp.16–29

Holcomb, A., 'Turner and Scott', *Journal of the Warburg and Courtauld Institutes*, 1971, vol.34, pp.385–97

Hunnisett, B., *Steel-Engraved Book Illustration in England*, 1980

Lyles, A. and Perkins, D., *Colour into Line: Turner and the Art of Engraving*, exh. cat., Tate Gallery 1989

National Gallery of Scotland, *Turner's Illustrations for the Poetical Works of Thomas Campbell*, exh. leaflet, Edinburgh 1988

Omer, M., *Turner and the Poets*, exh. cat., Marble Hill House, 1975

Pointon, M., *Milton and English Art*, Manchester, 1970

Powell, C., 'Turner's Vignettes and the Making of Rogers' "Italy"', *Turner Studies*, vol.3, no.1, 1983, pp.2–13

Powell, C., *Turner's Rivers of Europe: The Rhine, Meuse and Mosel*, exh. cat., Tate Gallery 1991

Rawlinson, W.G., *The Engraved Work of J.M.W. Turner*, 2 vols., 1908 and 1913

Rodner, W.S., 'Turner's Dudley: Continuity, Change and Adaptability in the Industrial Black Country', *Turner Studies*, 1988, vol.8, no.1, pp.32–40

Royal Academy of Arts, *Turner 1775–1851*, catalogue of bicentenary exh., 1974–5

Ruskin, J., *Notes by Mr Ruskin on his Collection of Drawings by the late J.M.W. Turner, R.A. Exhibited at the Fine Art Society's Galleries*, 1878

Serota, N., 'J.M.W. Turner's Alpine Tours', M.A. Report (unpublished), The Courtauld Institute of Art, 1970

Shanes, E., *Turner's Picturesque Views in England and Wales 1825–1838*, 1979

Shanes, E., *Turner's England 1810–38*, 1990

Snodin, M. (ed.), *Karl Friedrich Schinkel: A Universal Man*, exh. cat., Victoria and Albert Museum 1991

Stainton, L., *Turner's Venice*, 1985

Thornbury, W. G., *The Life of J.M.W. Turner R.A.*, second ed., 1897

Wainwright, C., *The Romantic Interior: The British Collector at Home 1750–1850*, 1989

Wallace-Hadrill, D. and Carolan, J., 'Turner North of Stirling in 1831; a Checklist', pts. (1) and (2), *Turner Studies*, vol.10, no.1, 1990, pp.12–22 and vol.10, no.2, 1990, pp.25–33.

Warrell, I., *Turner: The Fourth Decade, Watercolours 1820–30*, exh. cat., Tate Gallery 1991

Whittingham, S., 'The Turner Collector: Benjamin Godfrey Windus 1790–1867', *Turner Studies*, 1987, vol.7, no.2, pp.29–35

Wilcox, T. (*et al.*), *Visions of Venice: Watercolours and Drawings from Turner to Procktor*, exh. cat., Bankside Gallery 1990

Wilkinson, G., *Turner's Colour Sketches, 1820–34*, 1975

Wilton, A., *Turner in the British Museum*, exh. cat. 1975

Wilton, A. and J. Russell, *Turner in Switzerland*, Zurich, 1976

Wilton, A., *The Life and Work of J.M.W. Turner*, 1979

Wilton, A., *Turner and the Sublime*, exh. cat., British Museum 1980

Wilton, A., *Turner Abroad: France, Italy, Germany, Switzerland*, 1982

Wilton, A., *Turner in his Time*, 1987

Wilton, A., *Turner Watercolours in the Clore Gallery*, second ed., 1988

Wilton, A., 'The "Keepsake" Convention: Jessica and Some Related Pictures', *Turner Studies*, 1989, vol.9, no.2, pp.14–33

Wilton, A., *Painting and Poetry: Turner's 'Verse Book' and his Work of 1804–1812*, exh. cat., Tate Gallery 1990